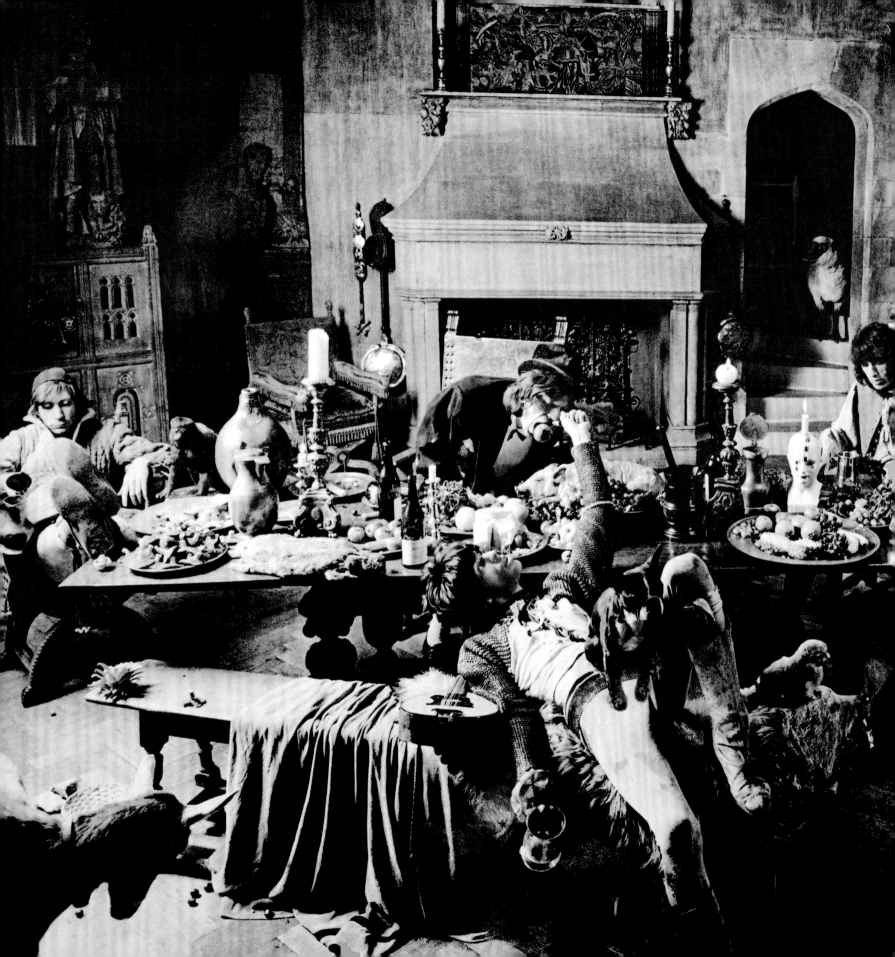

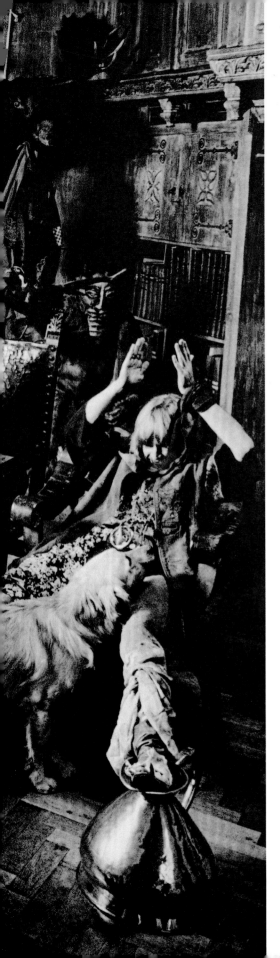

ROLLING STONES 50X20

Edited By Chris Murray
Foreword by Richard Harrington
Afterword by Chris Salewicz

The Photographs of

Gus Coral, Bob Bonis, Eric Swayne,
Gered Mankowitz, Jan Olofsson, Eddie Kramer,
Michael Joseph, Barry Feinstein, Baron Wolman,
Michael Cooper, Michael Putland, Bob Gruen,
Mark Weiss, Chris Makos, William Coupon,
David Fenton, Claude Gassian, Ross Halfin,
Mark Seliger, Fernando Aceves

INSIGHT ◉ EDITIONS

San Rafael, California

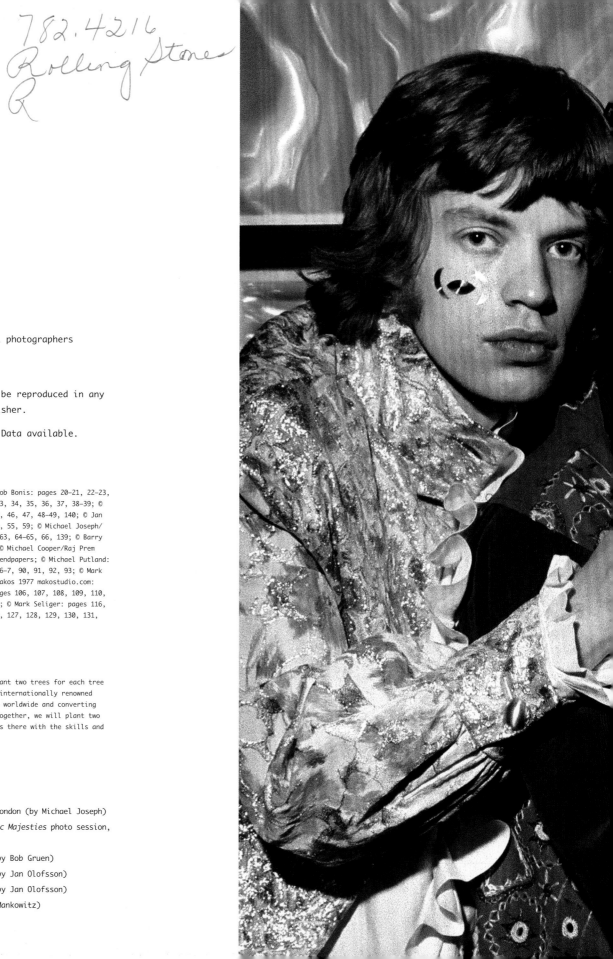

INSIGHT EDITIONS

PO Box 3088
San Rafael, CA 94912
www.insighteditions.com

INSIGHTEDITIONS.COM
FOR WEB EXCLUSIVE CONTENT!

Find us on Facebook: www.facebook.com/InsightEditions

Follow us on Twitter: @insighteditions

Photo Credits

© Gus Coral: front flap, pages 13, 14, 15, 16, 17, 18, 19; © Bob Bonis: pages 20–21, 22–23, 24–25, 26, 27, 28, 29, 30, 31; © Eric Swayne: back flap, 32, 33, 34, 35, 36, 37, 38–39; © Gered Mankowitz: front endpapers, pages 11, 41, 42, 43, 44, 45, 46, 47, 48–49, 140; © Jan Olofsson: pages 8, 9, 50, 51, 52, 53; © Eddie Kramer: pages 54, 55, 59; © Michael Joseph/ Raj Prem Collection: front cover, case, pages 2–3, 60, 61, 62–63, 64–65, 66, 139; © Barry Feinstein: pages 67, 68–69; © Baron Wolman: pages 71, 72, 73; © Michael Cooper/Raj Prem Collection: pages 4–5, 75, 76–77, 78, 79, 80–81, 82, 83, back endpapers; © Michael Putland: pages 84, 86, 87, 88, 89, 135; © Bob Gruen: back cover, pages 6–7, 90, 91, 92, 93; © Mark Weiss: pages 94, 95, 96, 97, 98, 99, 100, 101; © Christopher Makos 1977 makostudio.com: page 103; © William Coupon: pages 104, 105; © David Fenton: pages 106, 107, 108, 109, 110, 111; © Claude Gassian: pages 112, 113; © Ross Halfin: page 115; © Mark Seliger: pages 116, 117, 118; © Fernando Aceves: pages 120, 122, 123, 124–125, 126, 127, 128, 129, 130, 131, 133, 136

ROOTS of PEACE REPLANTED PAPER

Insight Editions, in association with Roots of Peace, will plant two trees for each tree used in the manufacturing of this book. Roots of Peace is an internationally renowned humanitarian organization dedicated to eradicating land mines worldwide and converting war-torn lands into productive farms and wildlife habitats. Together, we will plant two million fruit and nut trees in Afghanistan and provide farmers there with the skills and support necessary for sustainable land use.

Manufactured in China by Insight Editions

10 9 8 7 6 5 4 3 2 1

Pages 2–3: 1968, the Rolling Stones, *Beggars Banquet*, London (by Michael Joseph)
Right: 1967, the Rolling Stones, "Eleven Hands," *Satanic Majesties* photo session,
 New York (by Michael Cooper)
Pages 6–7: 1972, Mick Jagger, Madison Square Garden (by Bob Gruen)
Page 8: 1966, Brian Jones, *Ready Steady Go*, Wembley (by Jan Olofsson)
Page 9: 1966, Mick Jagger, *Ready Steady Go*, Wembley (by Jan Olofsson)
Page 11: 1965, the Rolling Stones, America (by Gered Mankowitz)

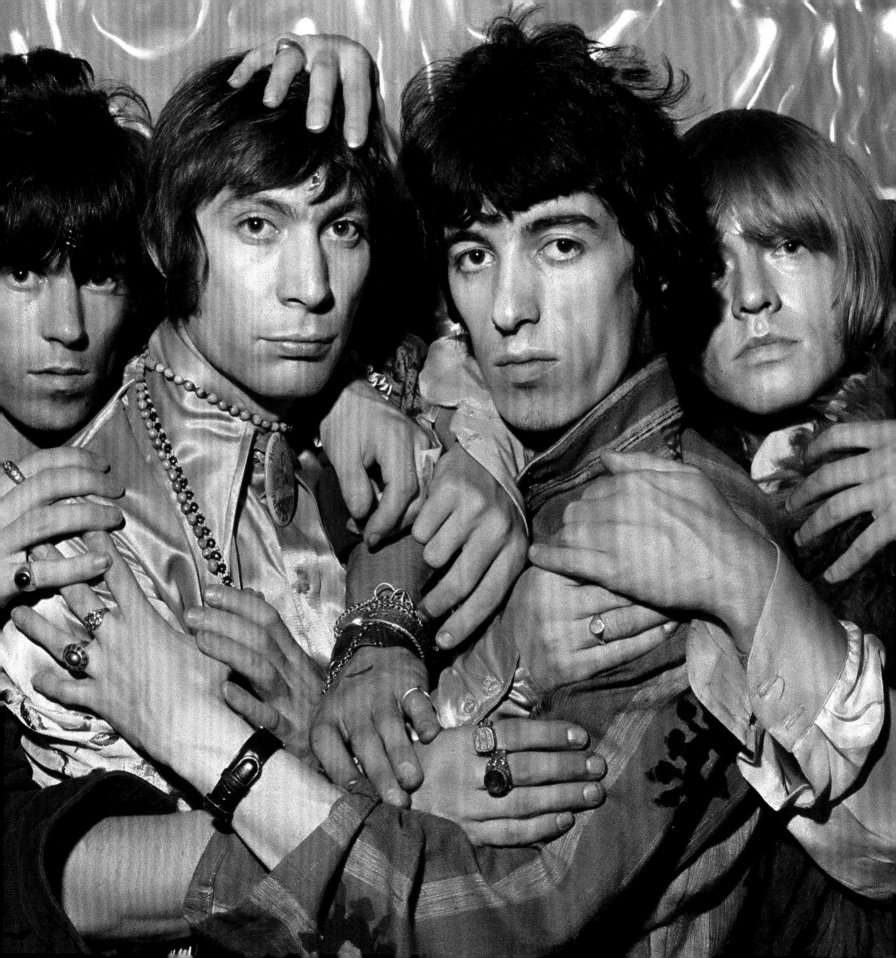

CONTENTS

F O R E W O R D

*A*s the quintessential rock 'n' roll band, the *Rolling Stones* have embraced, defied, twisted—and ultimately embodied—every imaginable rock 'n' roll cliché and stereotype. They probably could have done it without making a sound.

Witness this silent book, which is nonetheless loud, rambunctious, chaotic, flamboyant, dangerous—all qualities attached to the Stones' music, and to their lives, but just as appropriate to their look. Like their music, the *Rolling Stones'* style is audacious and electrifying. To see them is to hear them.

Little wonder that photographers have always loved them: *Rolling Stones* pictures come with implied sound tracks. That's true even of the relatively airy innocence of the early days—so many days ago, fifty years' worth now—when everything seemed as possible as it should have been impossible, before the Stones' single-minded devotion to gritty American blues, rock and rhythm 'n' blues led to the discovery of their own distinctive voices. Which led to the hysteria of the turbulent '60s and those perpetually rumbling undercurrents of danger—as much to the Stones themselves as to the culture of the times. After that, the gargantuan operatic concert forays of the '70s and '80s, and the glamorous ennui of men of wealth and curious tastes living in exile.

They were decadent dandies transformed into rock 'n' roll highwaymen, iconoclasts who became icons. With the tragic exception of cofounder Brian Jones—perhaps the most gifted, curious, provocative, and fashionable Stone, he flamed out

quickly—the band managed to outlast its contemporaries and outlive most of its addictions. They began calling themselves "The World's Greatest Rock 'n' Roll Band" in the late '60s, and have reclaimed the title every decade since. How intriguing that their first American hit was a cover of Buddy Holly's "Not Fade Away," their first Top 10 a cover of Irma Thomas' "Time Is on My Side." Time has indeed stayed on their side and the images have refused to fade away.

And what glorious subjects they have been, particularly Mick Jagger, rock 'n' roll's most famous hybrid—half rooster, half satyr—and always the center of attention with his feral physique, liquid hips, and pouty lips. In sex, drugs, and rock 'n' roll, Jagger was the sex; glimmer, sometimes grimmer, twin Keith Richards the drugs. Rock 'n' roll was the combustible consequence of their partnership, and almost every picture tells the story of a relationship as unsinkable as it is unstable.

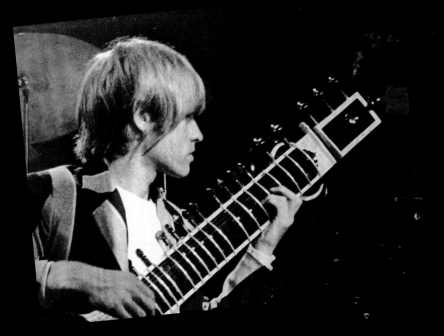

As photo subjects, Bill Wyman and Charlie Watts are like their bass playing and drumming: solid, immutable, dependable presences. The guitarists—the doomed Jones, the unconvinced Mick Taylor, the inevitable Ron Wood—are crucial, but never central. Even in the increasingly self-contained world of the **Rolling Stones**, it's Jagger and Richards who command the camera's eye to themselves.

Photographs can lie, but these don't. Some are pure documentary gold. Some were done with publicity clearly in mind, and some were unconscious propaganda; when you sense that eyes and lenses are always on you, you slip into poses and attitudes without necessarily being aware of it. For the most part, the **Rolling Stones** were perpetually self-aware—any kind of royalty requires the assumption of more than crowns. But they also knew who to trust, who to be unguarded with.

Which leads to this particular accumulation of historic images by many of the very best chroniclers of the **Rolling Stones** phenomena. Turn the pages and listen ...

—Richard Harrington

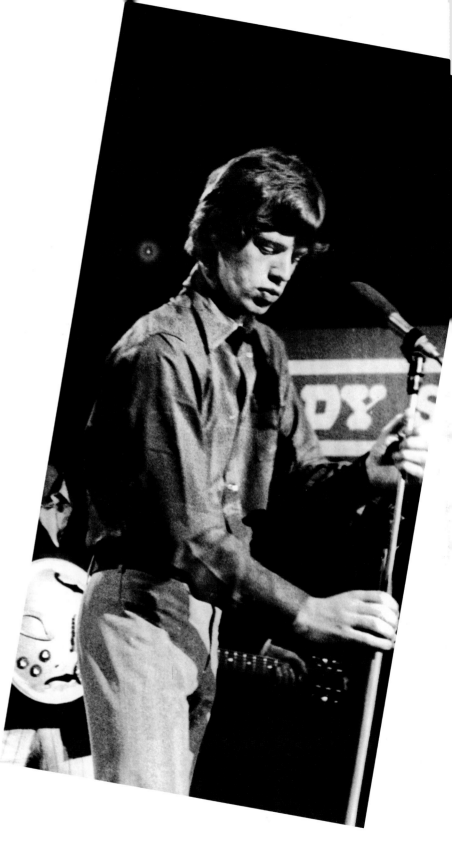

I n t r o d u c t i o N

Half a century . . . fifty years. Who would have imagined it? Probably the last ones to do so would be the **Rolling Stones** themselves. The Stones' bass player Bill Wyman started collecting memorabilia from the band's first show so he could someday prove to his son that he really had been in a rock 'n' roll band, never thinking that the Stones would last. Bill's collection is monumental now.

Keith Richards writes in his autobiography, *Life*, about his expectations of the band's longevity in the late sixties: "We'd run out of gas. I don't think I realized it at the time, but that was a period where we could have foundered—a natural end to a hit-making band."

Journalists and fans alike started talking and wondering decades ago about how long the band could possibly keep going. Weren't the **Stones** getting too old for rock 'n' roll? As the speculation continued, so did the **Rolling Stones**.

A different dialogue went on in my mind. I remembered the great blues musicians that I enjoyed so much, who also inspired the **Rolling Stones**. The **Stones** are in fact named after a Muddy Waters' song. Brian Jones came up with the name spontaneously while on the phone placing an advert in *Disc* magazine for the new band's first gig. A copy of the album *The Best of Muddy Waters* was nearby; the first song was "Rollin' Stone Blues." Musical artists such as Robert Johnson, Elmore James, John Lee Hooker, James Cotton, Solomon Burke, Slim Harpo, and Bo Diddley, among others, provided the **Rolling Stones** with their foundation. No matter their age, these great blues players and songwriters, the musical

DNA of rock 'n' roll, never stopped playing.

Similarly, jazz musicians inspired the band, and the great jazz players never stopped working. They were musical artists, and artists don't just stop at a certain age! They are inspired individuals—creative people who are compelled by their own work and the work of others, past and present, to "do their thing." When journalists started dismissing the **Stones** as being too old to play, I said to myself, "No way, why can't rock musicians keep playing just like the blues and jazz musicians do?"

I have always looked forward to how people like Keith Richards and Mick Jagger would help define and redefine rock 'n' roll music as they continued playing. The result of their longevity has been an amazing evolution of forms, melodies, and musical grooves. Like their great blues predecessors, the **Rolling Stones** "keep on keeping on." While the Stones became, and are, the penultimate "rock stars," first and foremost they are musical artists who are compelled by their own passion to make music, just like the blues and jazz musicians who came before them. As Muddy Waters sang, "A rolling stone don't gather no moss."

I had the good fortune of attending the **Rolling Stones'** first concert in New York City. It was June 20, 1964, and the Stones were playing afternoon and evening gigs at Carnegie Hall. I went to the afternoon show, and the Stones blew my mind.

I was a junior in high school in Manhattan. That year, a friend and I had started going to the Saturday afternoon concerts at Carnegie Hall. My initiation into live music was a truly amazing show by Ray Charles and his orchestra. We

also saw the Beach Boys and the Dave Clark Five. While leaving one of those concerts, we were handed a small card with a photo of the most unusual-looking band I had ever seen. The card read, "England's newest sensation, the **Rolling Stones**." We had never heard of them. It was Carnegie Hall's next show, and we decided to go.

Nearly fifty years have passed, but I will never forget the incredible buzz from that concert. It changed everything for me. The set included "Not Fade Away," "Walking the Dog," "Route 66," and "I Just Wanna Make Love to You," among others. I had not seen or heard anything like it since Elvis. The so-called "English Invasion" was on, but this was the first English band I saw that took American blues and R&B to rock 'n' roll.

Mick Jagger's dancing and singing were hot! Brian Jones's charisma was so strong he seemed to front the band. Keith was the root of it all musically, and Bill and Charlie were rock steady. Together, the **Rolling Stones** made all the girls scream.

Five decades later, the **Rolling Stones** are still rolling. No other musical group has endured like they have. The photographers in this book have documented many of the highlights from their amazing journey. Not only have the **Rolling Stones** given us some of the best rock 'n' roll music, but they have also given us a lot to look at. This book is a "tip-of-the-hat" to the greatest rock 'n' roll band in the world.

—Chris Murray

GUS
CORAL

*P*hotographing the Stones came by way of two friends of mine, Dick Fontaine, a documentary filmmaker, and James Miller, a graphic designer. We hung out together at the time. Dick was doing a five-minute spot in a half-hour program called *Tempo*, so we put our heads together to come up with the next big band. After talking to several people, the name *"The Rolling Stones"* came up. The next thing we heard is that they're doing a tour, and if we were quick we could catch up with them in Cardiff. So on the spur of the moment, Dick and I went to Cardiff and I took these photos.

At the concert in Cardiff, I was right in the wings of the stage. I had access. They didn't even think about security in those days. They didn't have minders and people to keep you out of certain areas. I was just there and the camera had a clear path. The big thing (and I didn't catch all of it) was the discussion about whether or not they would wear those houndstooth jackets. They almost didn't, and then decided they would. They preferred their street clothes, which were smarter in a casual kind of way.

After the concert, the *Stones* told us that they would be recording in the next couple of weeks and invited us to the EMI studios in Holborn. In the taxi shot, Holborn station is in the background. They were trying to get the cab fare together, you know, "Who's got five shillings?" or whatever. I was waiting for them at the door.

There was a different feel to the *Stones* in the studio shots compared to the stage shots. In the studio, they were surprisingly professional for a young band and just got on with the job without a great deal of larking—they just played the music. Mick definitely had a charisma that was immediately apparent. Brian was very vain (though not so much to me) and very particular about his appearance. I can remember his vanity, and I think that shows in some of the photos. I kind of warmed up to Charlie but it was hard because he is a very quiet, internal character...but I'm a bit like that as well. I thought he, rather than the others, was someone I could get along with personally. Keith was quiet, but so were the others. It was quite a subdued session. They were being serious about the music and getting the recording done.

I was a full-time, busy photographer then. I would photograph someone the day before and someone else the day after. Just another gig done for hire, mainly through word of mouth. But my work with the *Stones* in 1963 was close to my heart.

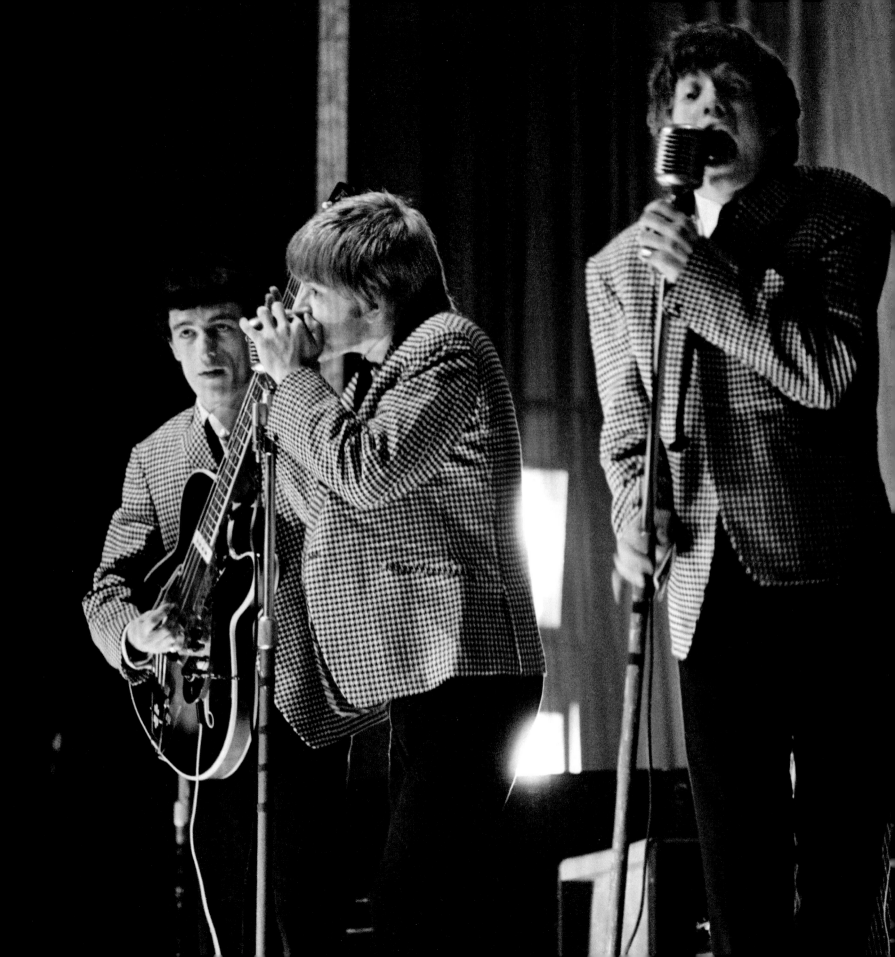

1963 BRIAN JONES AND MICK JAGGER, CARDIFF

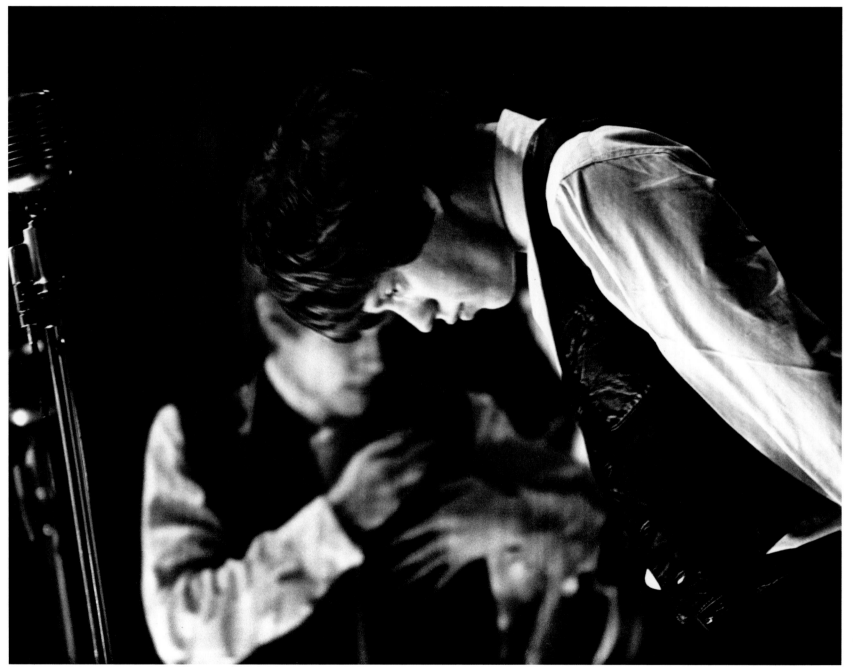

1963 BILL WYMAN, KEITH RICHARDS, AND BRIAN JONES, DE LANE LEA STUDIOS, LONDON

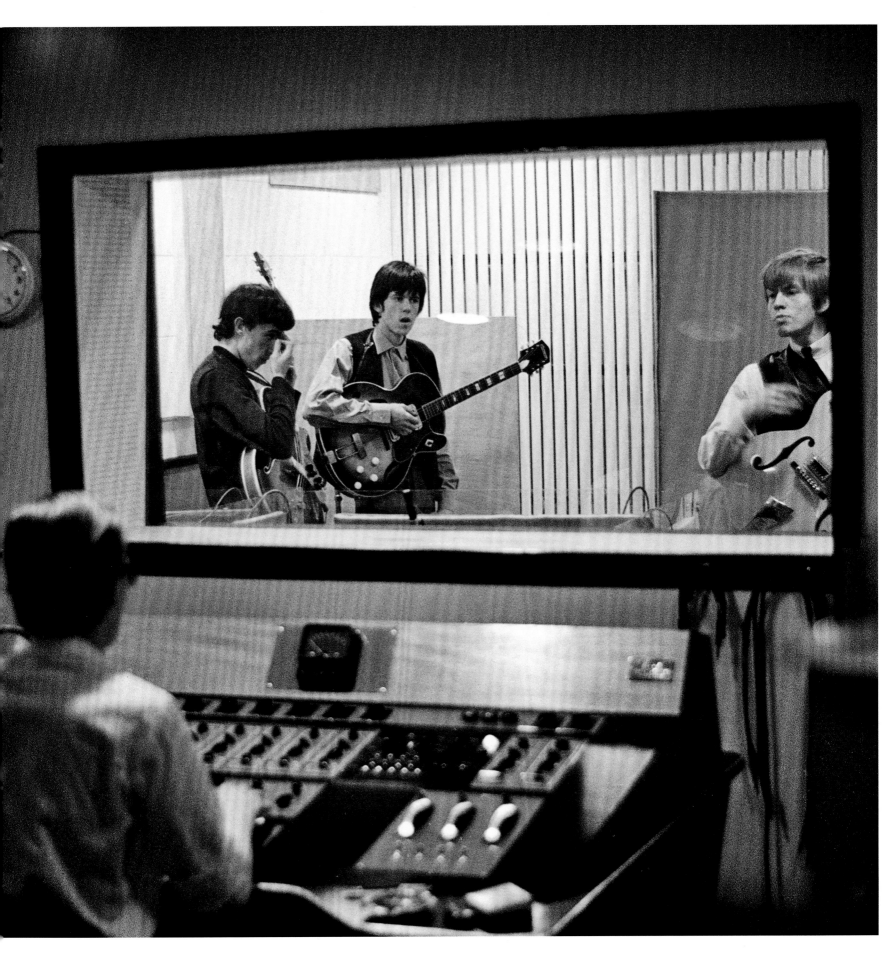

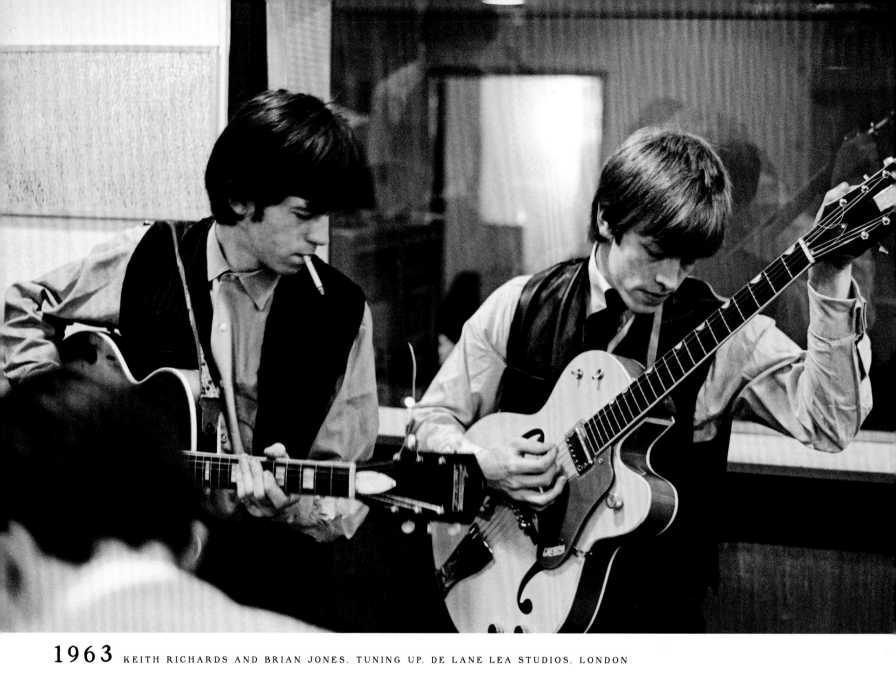

1963 KEITH RICHARDS AND BRIAN JONES, TUNING UP, DE LANE LEA STUDIOS, LONDON

1963 CHARLIE WATTS. DE LANE LEA STUDIOS. LONDON

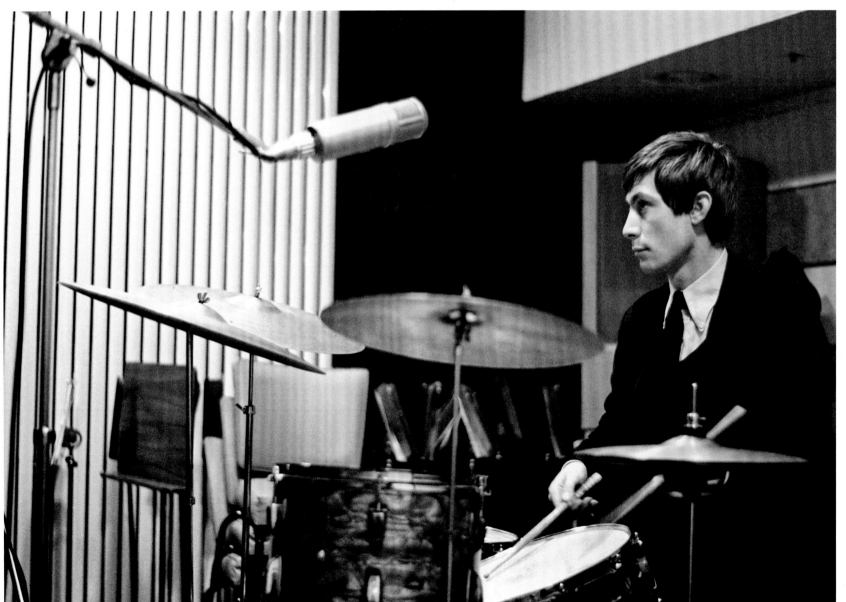

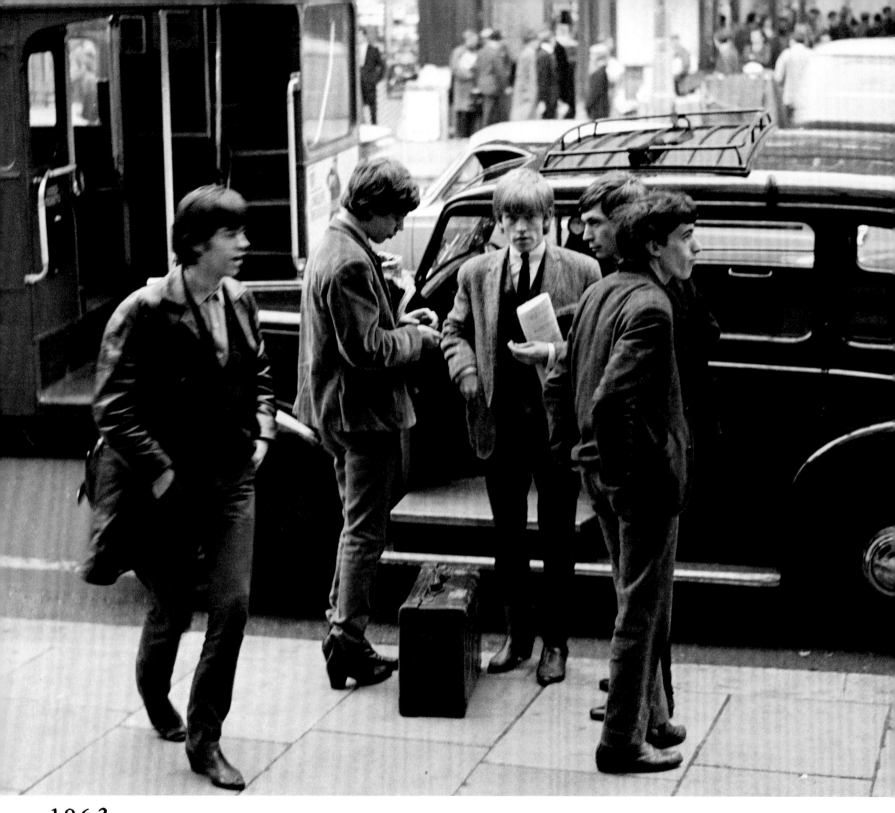

1963 KEITH RICHARDS. MICK JAGGER. BRIAN JONES. CHARLIE WATTS. AND BILL WYMAN.
OUTSIDE DE LANE LEA STUDIOS. LONDON

1963 MICK JAGGER, DE LANE LEA STUDIOS, LONDON

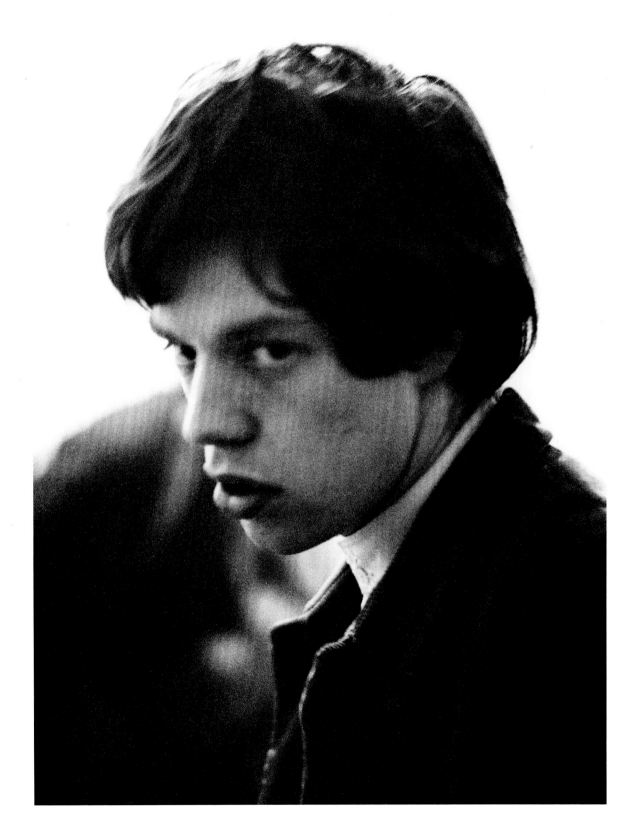

Bob
BONIS

In the late 1950s and early 1960s, Bob Bonis worked with jazz acts in the New York nightclubs, which in those days were all owned by mobsters. Bob earned a reputation in the business for not taking any guff from anybody and for standing up to the tough guys. Because of this, when England's "bad boys," the *Rolling Stones*, decided to come to America in early 1964, Bob was asked to sign on as their tour manager.

As it turns out, that "bad boys" reputation had been created by the band's manager, Andrew Loog Oldham, and Bob developed a close friendship with the band, particularly Charlie Watts because of their mutual interest in jazz. The Stones gave Bob carte blanche to shoot whenever and whatever he wanted. In the three years that he worked with them, 1964 through 1966, he took almost twenty-seven hundred photos of the band. He took some wonderful photographs that include the only known pictures of the band recording in Chess Studios in 1964 in Chicago. He took the only color photographs of them rehearsing and performing for the concert film *The T.A.M.I. Show*, which had been filmed in black and white. He took a tremendous number of iconic images of the Stones.

Bob was a passionate amateur photographer with natural talent who devoted many years to photographing different acts and musicians backstage and in recording studios, traveling and relaxing. Bob worked with a Leica M3, which he brought with him everywhere.

I think his photos are truly unique in that they show a side of the Stones that we, as fans, never got to see. Bob's photos are remarkable in that they are often stunningly unguarded and intimate. As the Stones tour manager, Bob was an insider and had access that virtually no one else was granted. This was the beginning of the British invasion, and there wasn't a backstage scene like there is today, with dozens of photographers shooting every second they can. In these candid shots, Bob was often the only person there besides the Stones.

—Larry Marion, curator of the Bob Bonis
Photographic Archive

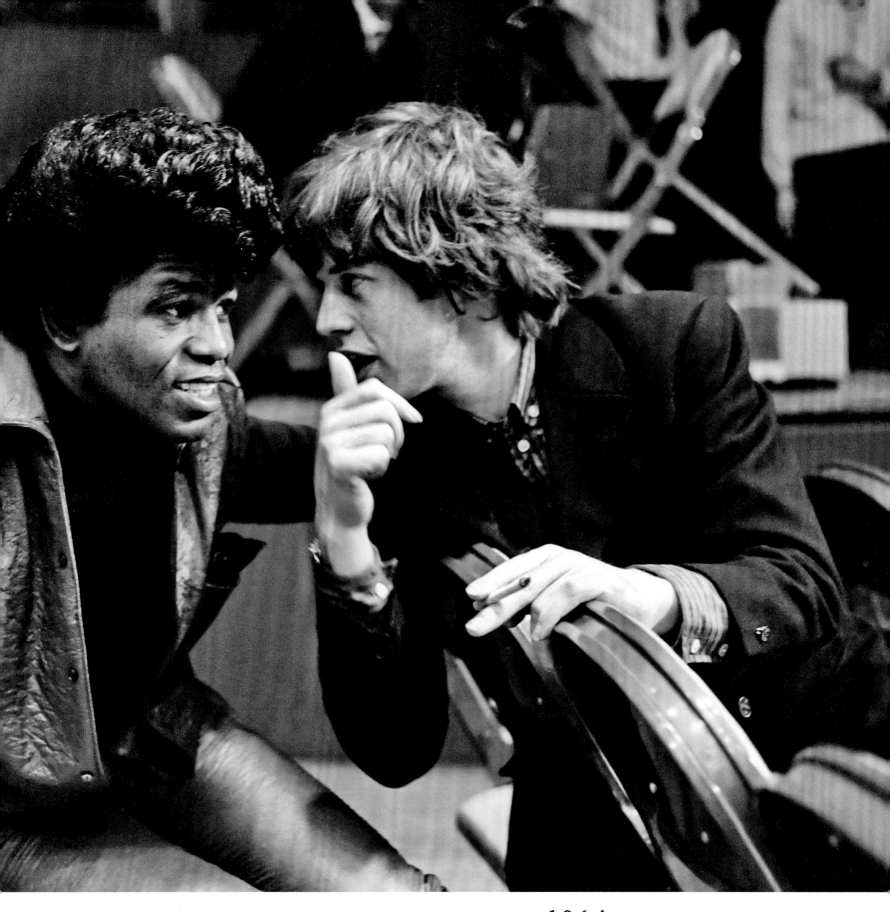

1964 JAMES BROWN AND MICK JAGGER.
THE T.A.M.I. SHOW. SANTA MONICA

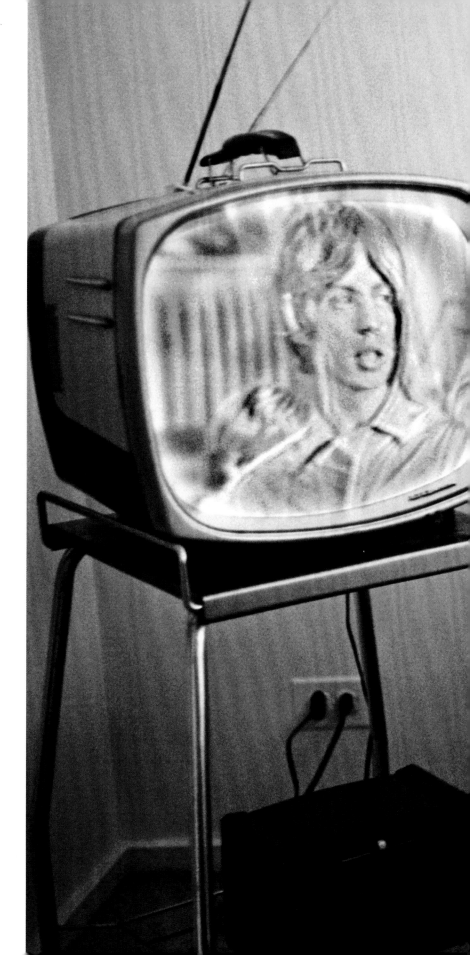

1964 MICK JAGGER, CHICAGO

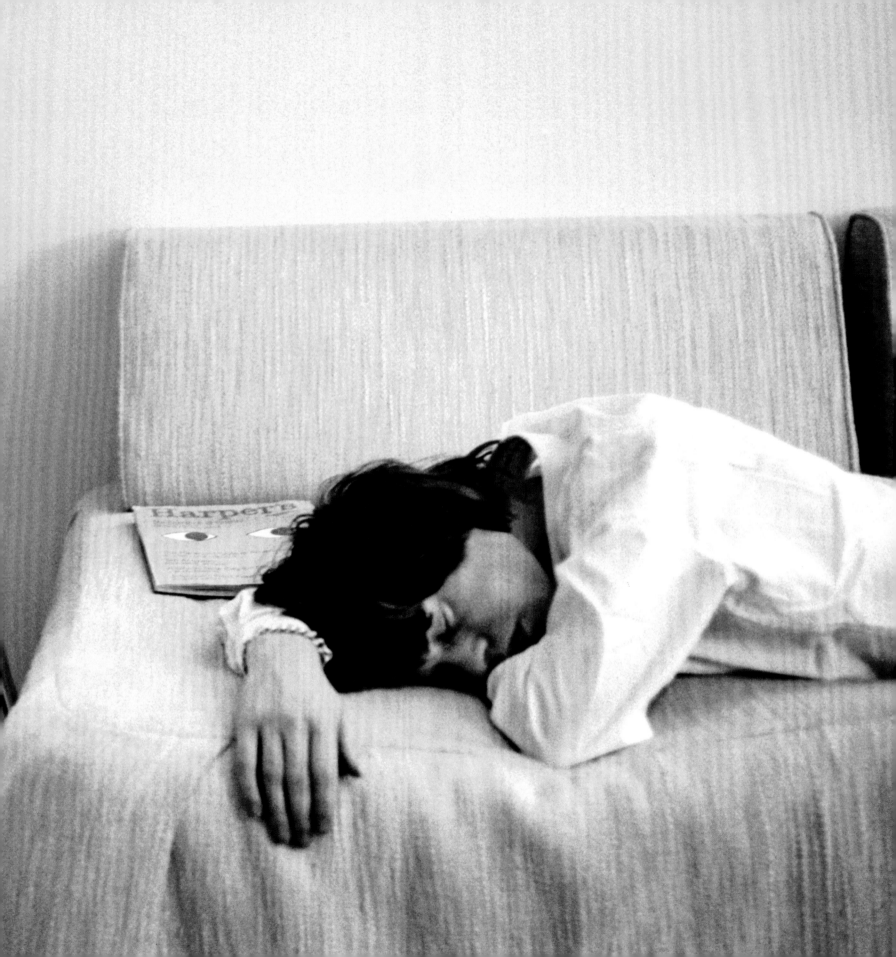

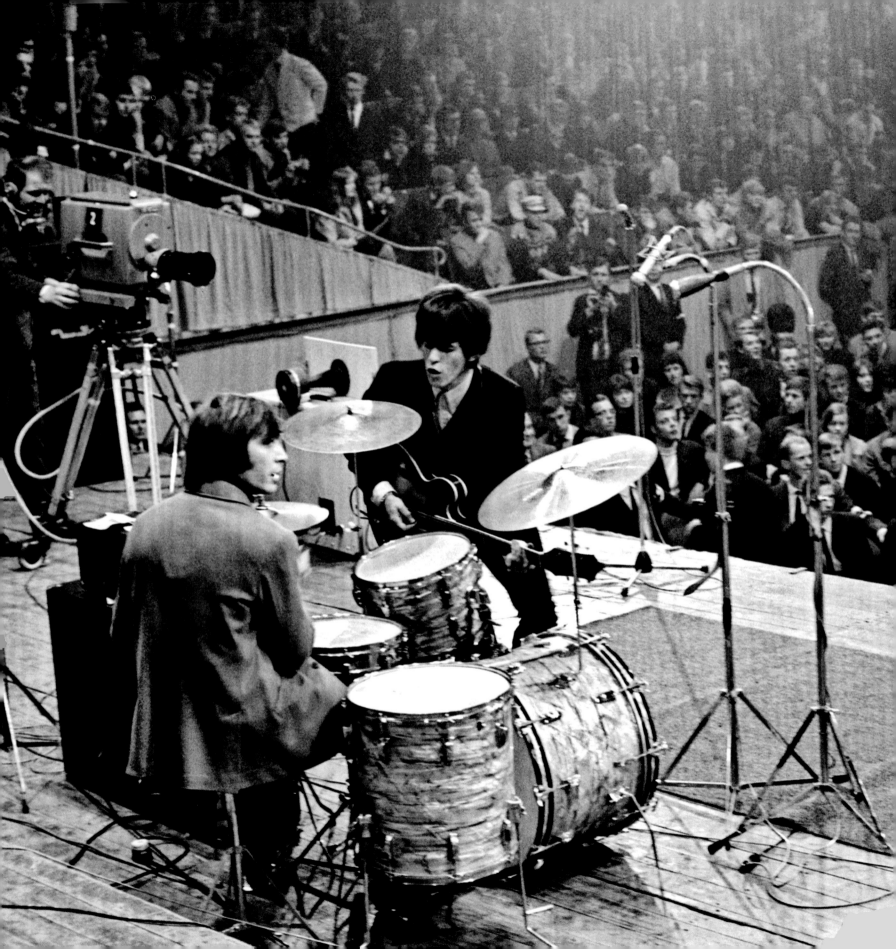

1965 KEITH RICHARDS AND CHARLIE WATTS. MUENSTER

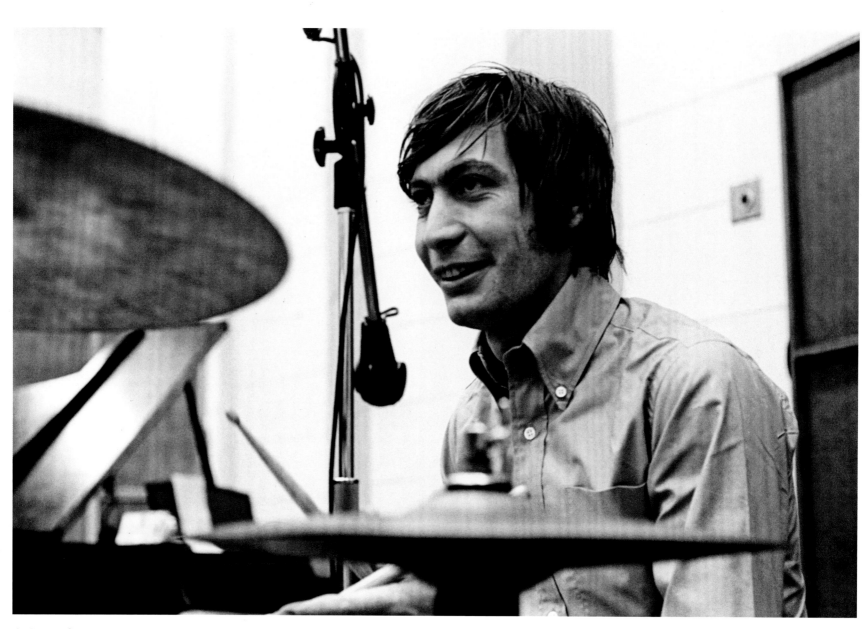

1965 CHARLIE WATTS, RCA STUDIOS, HOLLYWOOD

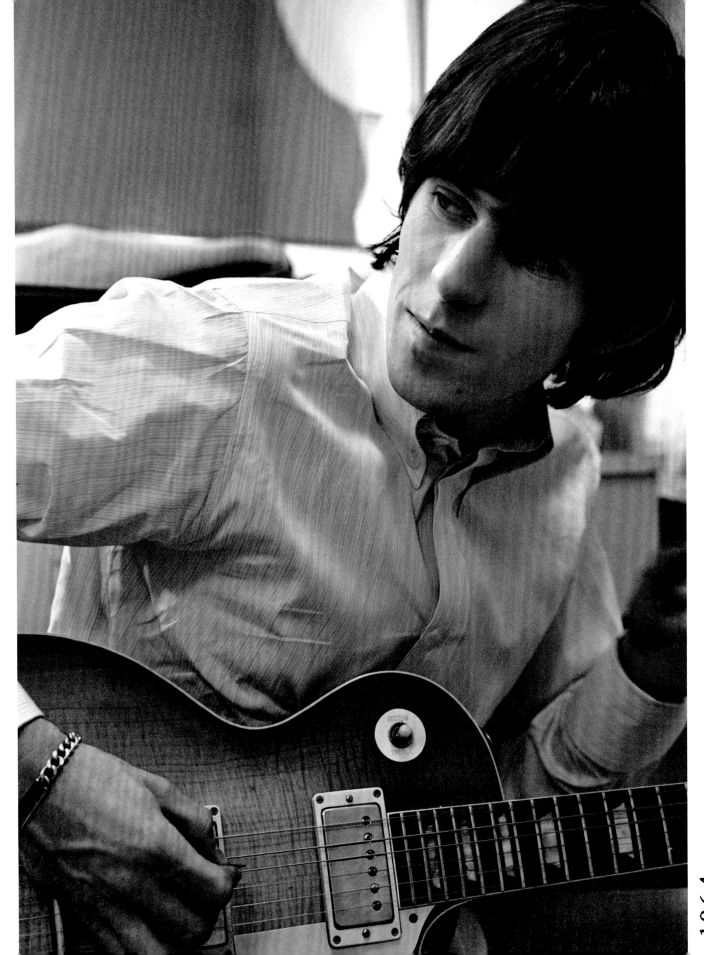

1964 KEITH RICHARDS. THE T.A.M.I SHOW. SANTA MONICA

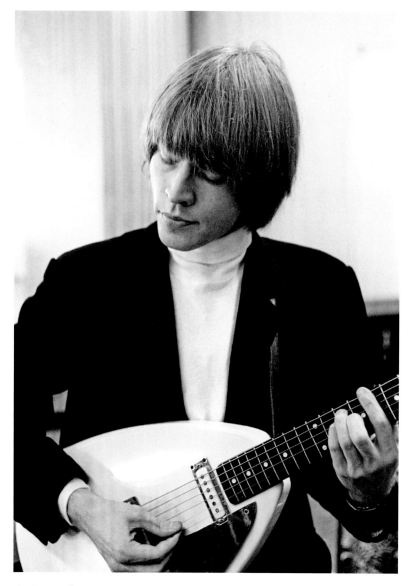

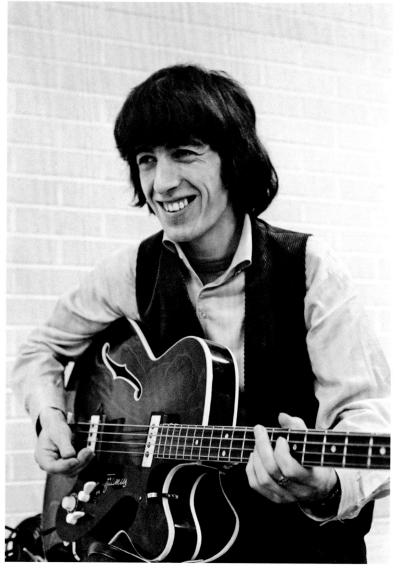

1965 BRIAN JONES. RCA STUDIOS. HOLLYWOOD

1965 BILL WYMAN. RCA STUDIOS. HOLLYWOOD

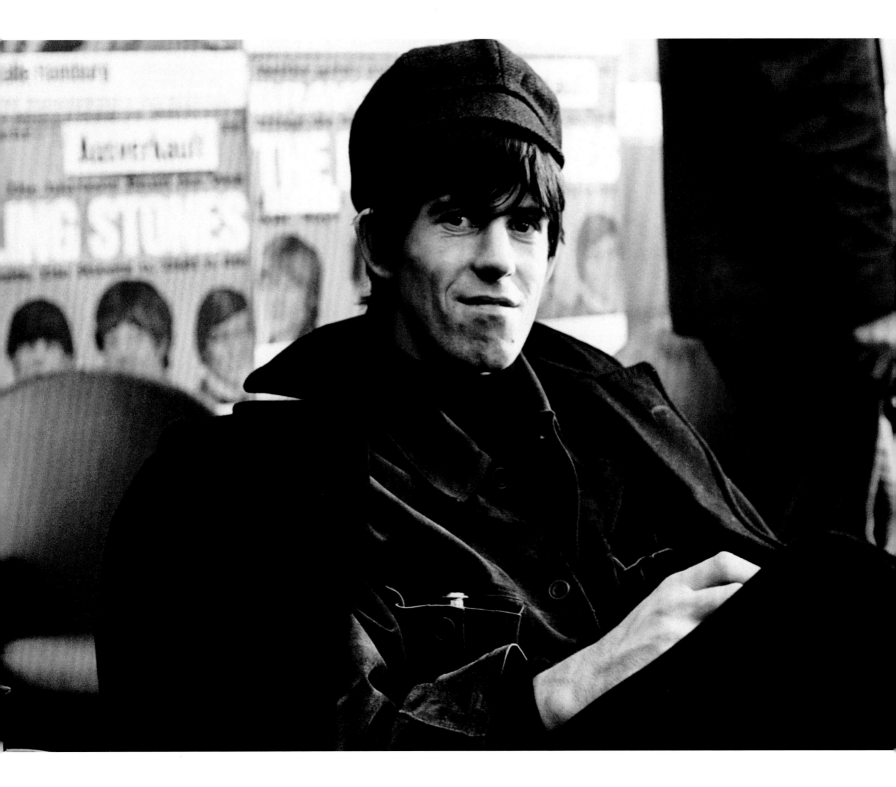

1965 KEITH RICHARDS. HAMBURG

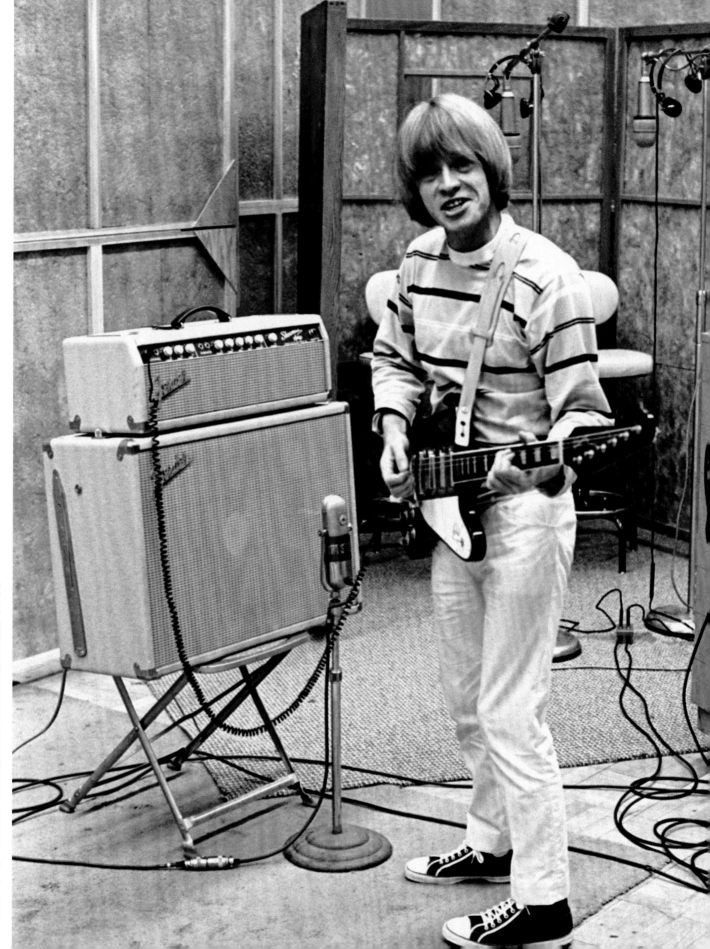

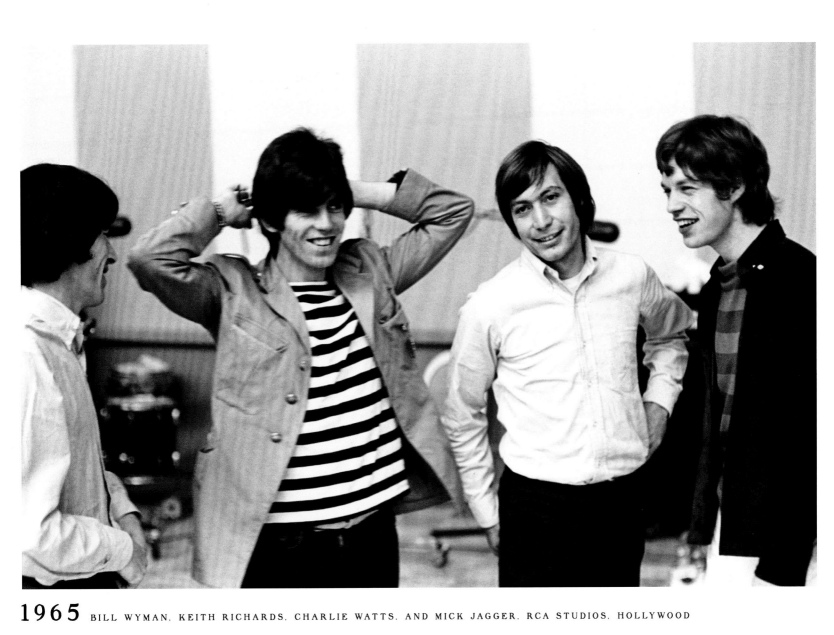

1965 BILL WYMAN, KEITH RICHARDS, CHARLIE WATTS, AND MICK JAGGER, RCA STUDIOS, HOLLYWOOD

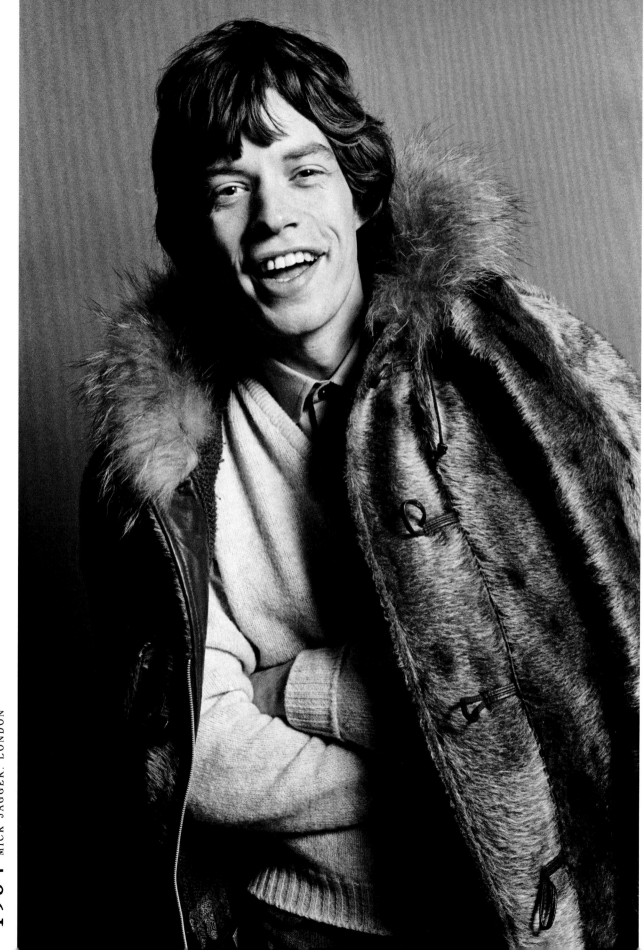

1964 MICK JAGGER, LONDON

In the 1950s, my dad, Eric Swayne, went off to Paris, where he discovered the city's amazing, glamorous, chic café society. To survive he worked as a nightclub singer but also as a barista. When he came back to London in 1960, there were a few coffee shops where his skills as a barista were highly prized, and those were the places where the cool crowd would hang out. Eric was very funny and looked great. He looked like a French film star and had amazing charisma. He met the well-known British photographers David Bailey and Brian Duffy (who shared his working-class London roots), and the doors of London's swinging sixties counterculture swung open. It was an exciting time in so many ways, and photography was very much part of it. There was all kinds of cross-fertilizing going on with aristocracy hanging out with gangsters and models with musicians.

London photographer Peter Rand was a great friend of Eric's and gave him his first Pentax camera, as he thought Eric would be a good photographer. Eric started taking pictures, and his first shots were of Pattie Boyd, whom he had met at a party and who eventually became his girlfriend. They were together for two years before she became George Harrison's wife. It was such a small scene then. Everyone was hanging out with everyone. He also photographed people like producer David Puttnam and actress Jacqueline Bisset. Eric started getting loads of advertising work, earned some money, and was living a life that previously he could only dream of. It was a classic sixties tale.

He lived in a block of flats in Chelsea called West London Studios, right by Chelsea football ground. This was where everyone was hanging out, partying, and taking pictures. My mum was a model, and she describes being there with my father when Keith Richards turned up quite early one morning. Keith had been out all night and was completely, deliriously off his face. Keith took my father shopping in a limo. He would buy one of everything in every color, and also buy the same for my dad, who would often go down with Keith to his country house at Redlands. This was a period where they were good friends.

The sequence with Mick in the fur coat is from 1964 and was a completely informal studio shoot. That was the same coat that Mick wore for his famous portrait taken by David Bailey. Mick was performing in front of the camera and was helping my dad learn how to take pictures in those early days.

Eric
SWAYNE
Text by his son, Tom Swayne

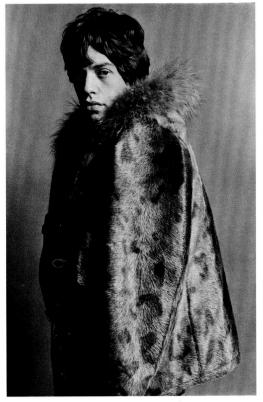

1964 MICK JAGGER, LONDON

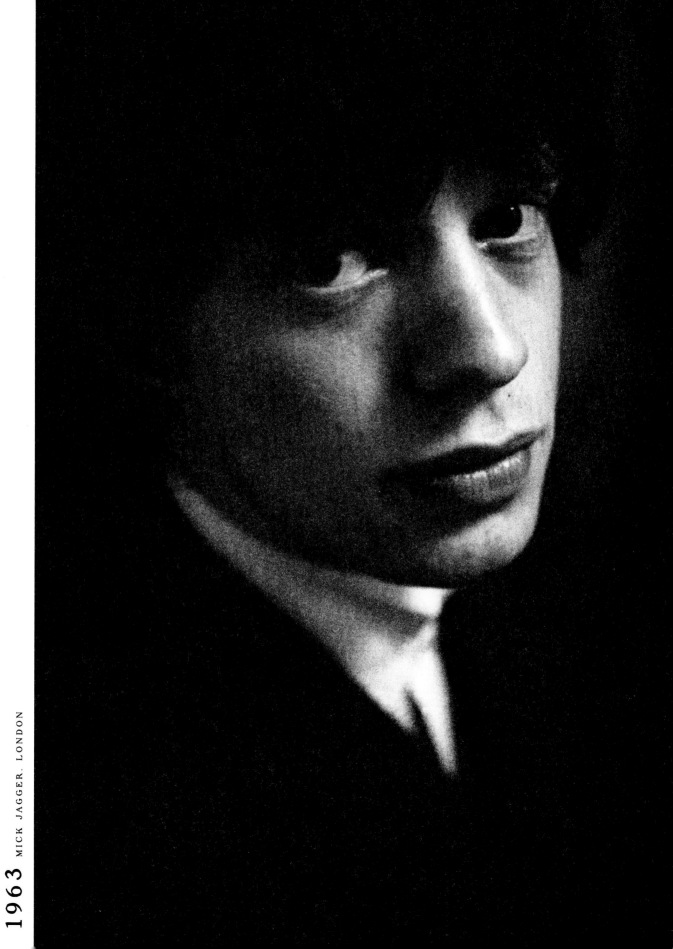

1963 MICK JAGGER. LONDON

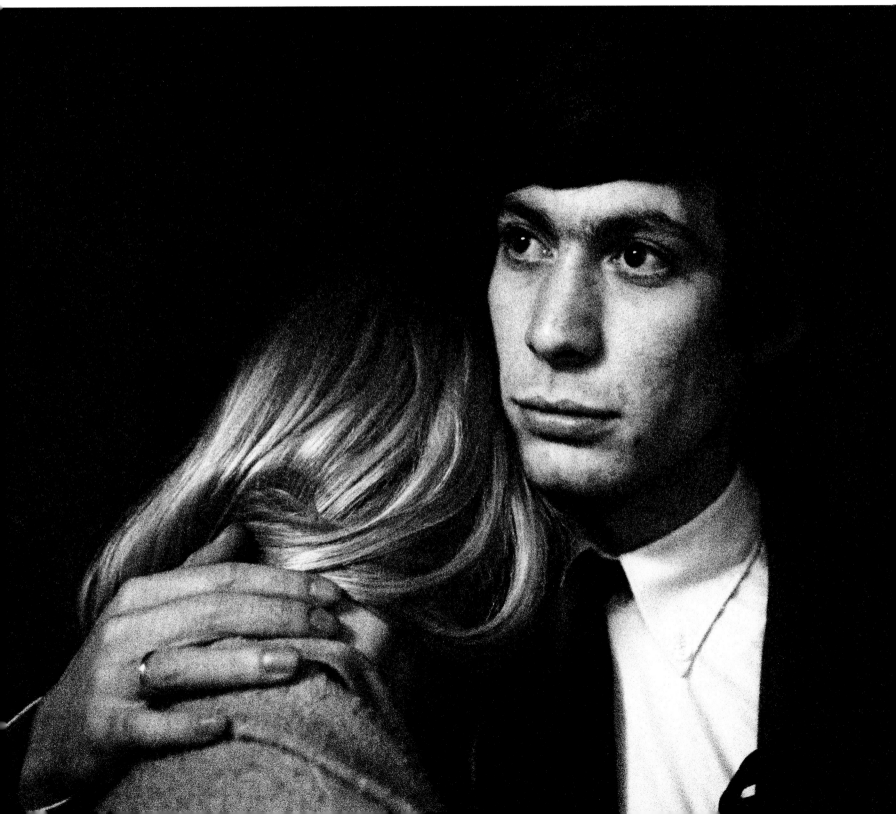

1964 KEITH RICHARDS. LONDON

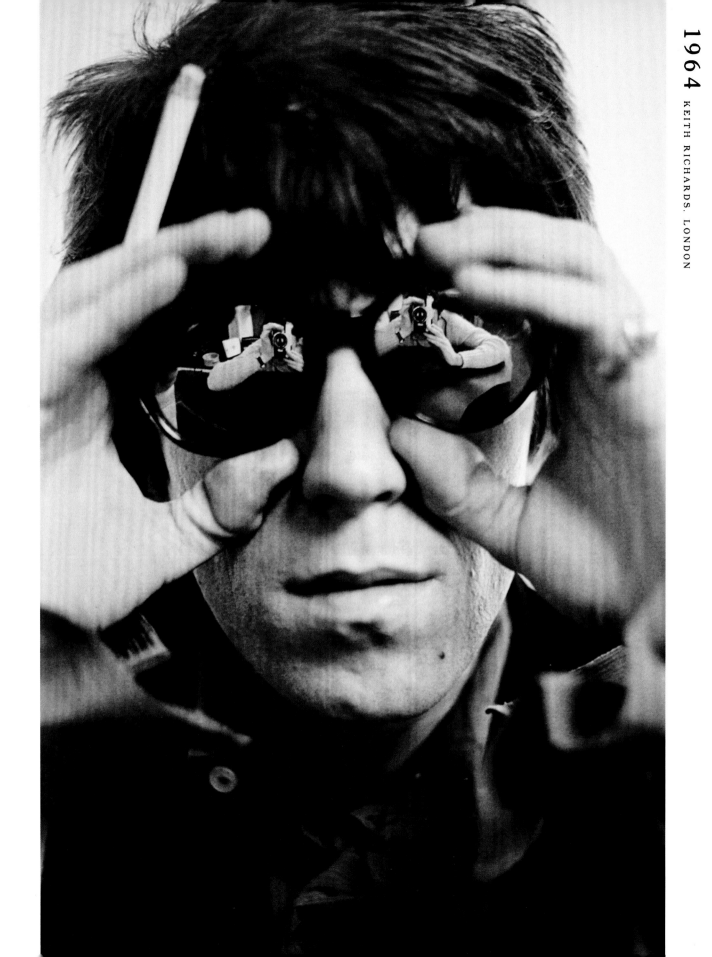

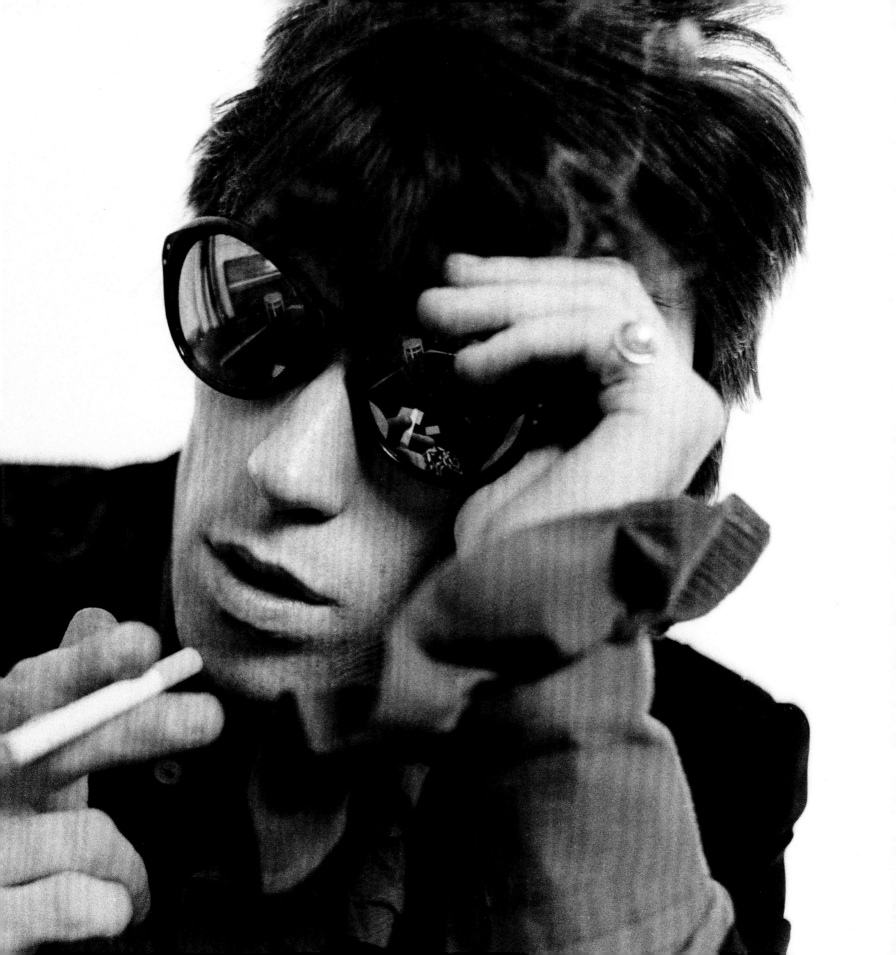

I was working with Chad and Jeremy,

an English duo who were a sort of folk-pop British version of the Everly Brothers, and they were appearing on a television show in 1964. Also on the show was Marianne Faithfull, who had just released "As Tears Go By." Chad and Jeremy brought Marianne back to London, and I joined the three of them for dinner. Instantly, I fell under Marianne's spell. She was bright and gorgeous, so I began photographing her within a few days. Her manager, Andrew Loog Oldham, who also managed the *Stones,* loved my pictures of Marianne and asked me to work with the Stones.

I had met Brian socially around the end of 1964, and I met all of them at Andrew's office once he had decided he wanted me to do a shoot. The first session I did with the Stones was in early 1965 at my studio in Mason's Yard. I took them out of the studio and into an adjacent space called Ormond Yard, where I photographed them. From that session came the cover of *Out of Our Heads*, or *December's Children*, as it was called in America. We had a fantastic time, very laid-back and informal. There were no publicists, stylists, or security; not even a roadie. It was just me and the guys. It was immensely exciting because they weren't the superstars they are today, but still, they were huge. "Satisfaction" wasn't due for release for another couple of months, and "The Last Time" was hitting the number one spot in the charts. Up until then, I'd been working with small acts with small labels, so the *Stones* was a massive leap for my career and incredibly exciting.

In the summer of that year, I got a call to say I was going to go on the tour. It was fantastic. I spent November and December in America on this extraordinary tour that covered forty-eight cities in sixty days. I was on stage with them every night. We ended up in Hollywood at RCA studios when "Get Off of My Cloud" was number one, and they were recording *Aftermath*. It was just a phenomenal whirlwind year for me, and for them, it was an extraordinary experience.

Throughout 1966, we did stuff around the UK, recording at Olympic Studios in Barnes in West London, and shooting home sessions with each of them, as well as the Primrose Hill *Between the Buttons* photographs after an all-night recording session. In these early days, Brian had the most-evolved image, a defined and refined charisma. Mick and Keith were a bit raggedy. There was a little bit of money by the end of 1965, but it didn't start coming through until 1966, when they got the cars and the houses. When I first met the *Stones,* there was a very exciting, youthful energy. Every single was a new adventure; every album was "My God, we got away with it. What's next?" They were having a great time and were working harder than any of them had been prepared for. Brian was still at the forefront of the band and really shared the spotlight with Mick in terms of fan worship and fanaticism. If you look at the pictures from 1965, the evolution of Keith's image is obvious from the beginning to the end of the year, when you see him in those cool shades, the leather jacket with the sheepskin collar, and the big Gibson Hummingbird guitar at RCA. Brian is just beginning to show signs of strain. Those pictures were taken less than a year after the first session in Ormond Yard.

Gered
MANKOWITZ

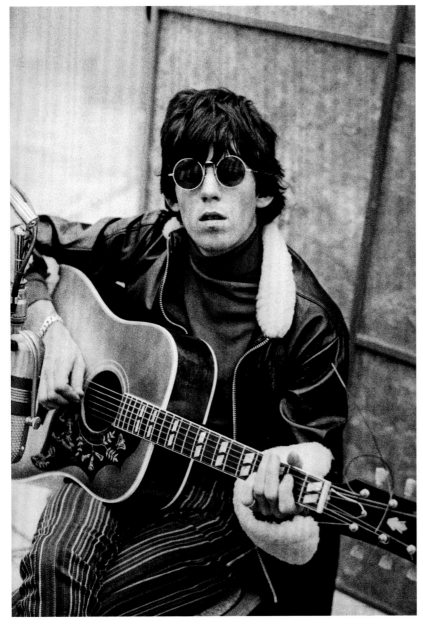

The Palladium in New York was raw and exciting. "Satisfaction" was their biggest hit yet and "Get Off of My Cloud'" was zooming up the charts. When they ended the show with "Get Off of My Cloud" the buzz was just fantastic. I can't hear that today without feeling that same feeling. Shooting at the Palladium and other shows felt very natural because they were at ease with me walking around during the shows. The vibration, both physical and emotional, was immense. You felt the music through your feet and you felt the extraordinary power of the kids who were just screaming and loving it. Sure enough, some girl would break through, leap on stage, and wrap herself around Brian before anyone knew it. A pile of palpitating teenagers would be in the back. Mick just manipulated the audience into an absolute frenzy night after night. The whole experience was electric.

They would rush off the stage and would be at the airport before anyone realized the show was over. I was so inexperienced and amateurish in the way I managed everything. I didn't run around with my camera around my neck. I had a little metal camera case containing my Hasselblad and my Nikon cameras and lenses, and I had to get all my stuff packed and in the limo quickly, in danger of being left behind. I didn't take pictures after the shows; we'd get on the plane, have dinner, arrive at three o'clock in the morning and be whisked to our hotel in some other God-forsaken place—like Raleigh, North Carolina—or in some dead city sitting there with no girls, no drugs, and no place open to get booze. It was a bizarre but fantastic, and educational, routine that changed my career.

Then there was 1967. I shot some of the *Satanic Majesties* recording sessions, but the relationship between Andrew and the band and, consequently, me and the band, started falling apart, along with Brian. It was a very difficult and strange time.

Not many of the sixty-five tour photos got used very much at the time and remained in my archive for many years, basically unseen. In recent years, the **Stones** have bought and published several of my photos in tour programs and various other "official" publications, because they caught the band at the peak of their initial success. "Satisfaction" and "Get Off of My Cloud" were brilliant rock songs, and everything was right. Brian was still a really active, important contributing member of the **Stones.** In terms of the initial energy, 1965–66 was a fantastic vintage. How lucky was I to be around for that moment, that period—it was fantastic!

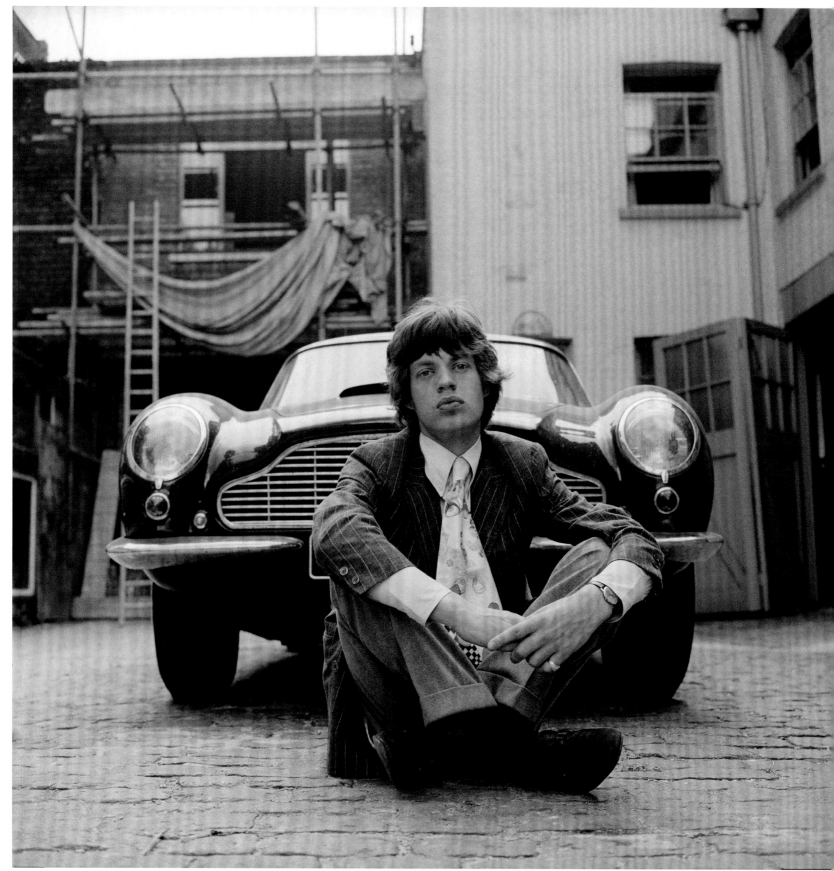

1966 MICK JAGGER WITH ASTON MARTIN. LONDON

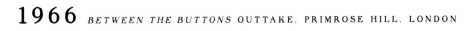

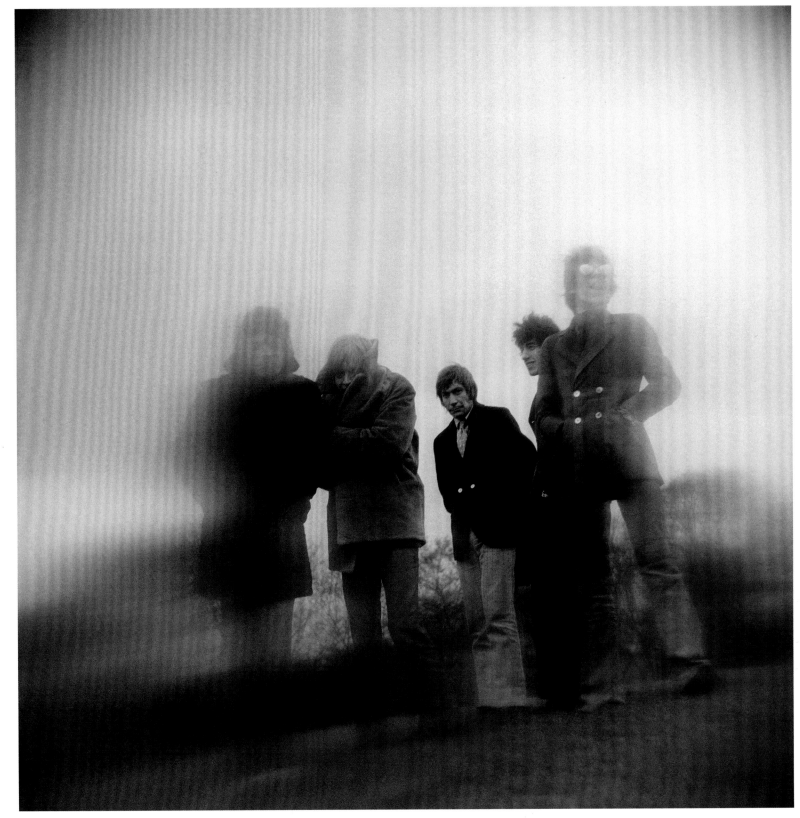

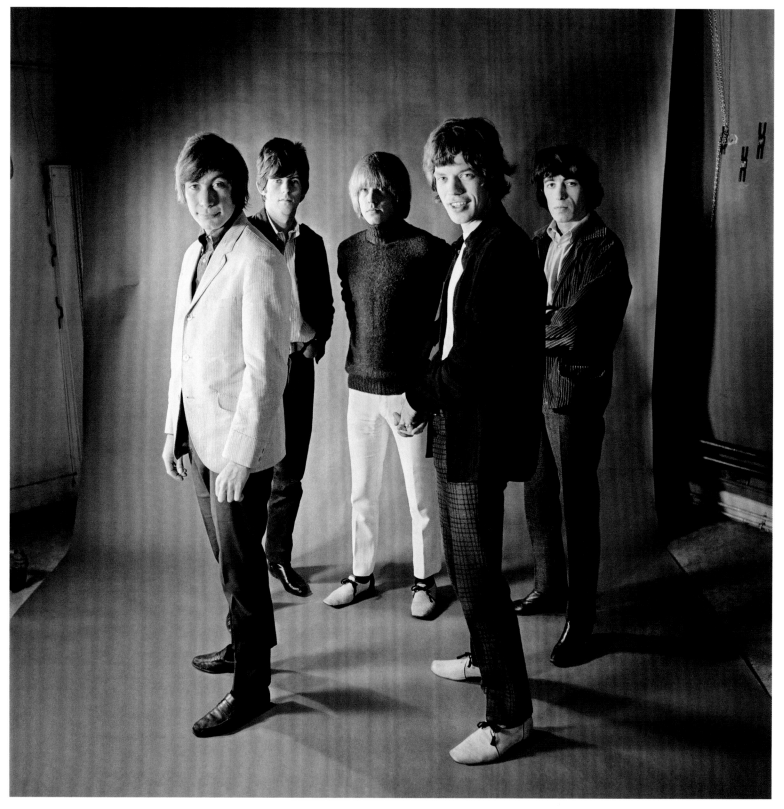

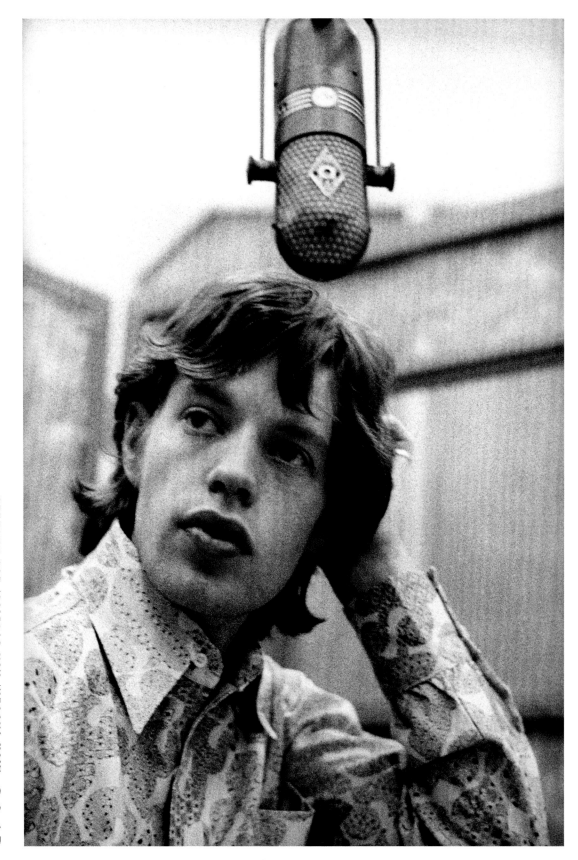

1965 MICK JAGGER. RCA STUDIOS. LOS ANGELES

1965 KEITH RICHARDS AND BILL WYMAN. AMERICAN TOUR

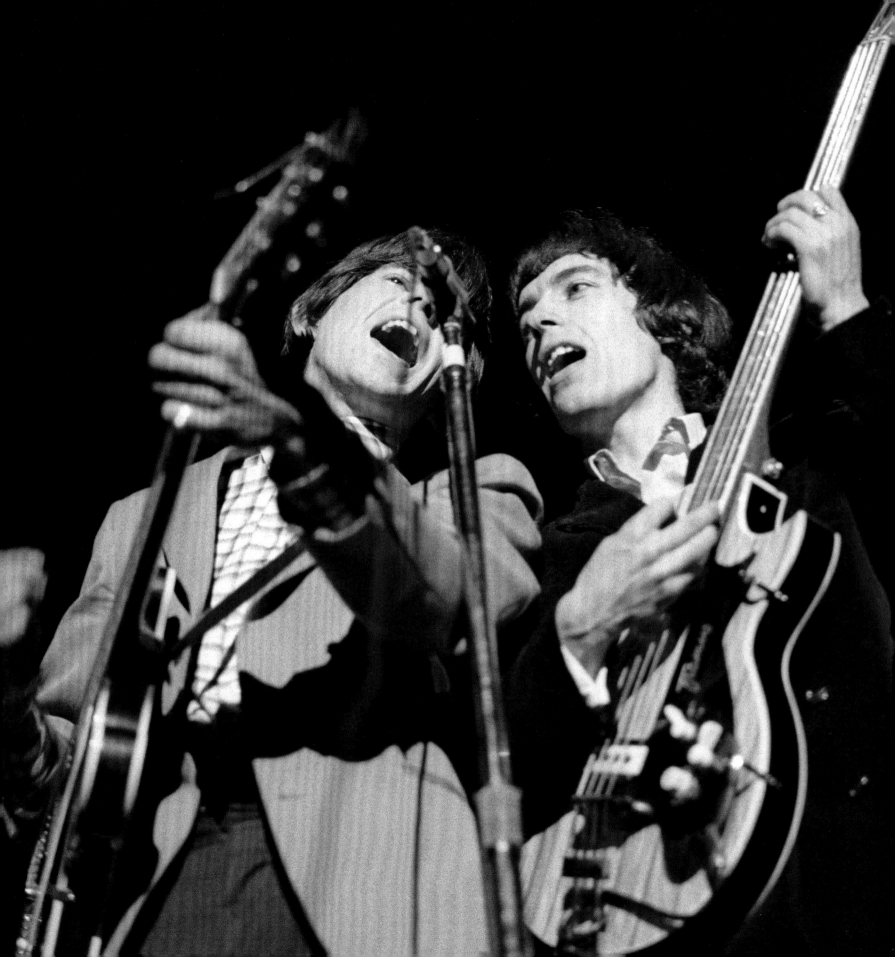

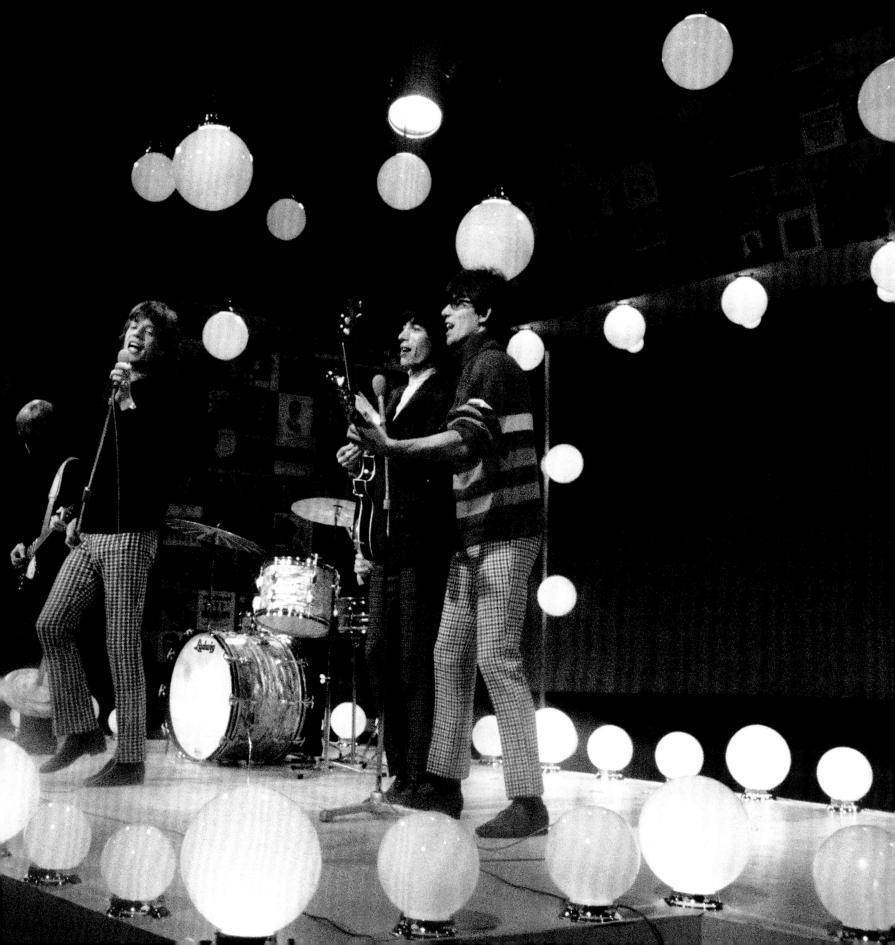

The Stones photographs were taken on the set of a TV show called *Ready Steady Go* with a live audience in Wembley. I was writing a monthly column for a Swedish magazine to earn some money, and I used to go there regularly. I wasn't really aware at the time of trying to take a great shot. It was all done on my own and without flash, only with available lighting. I made three pounds and three shillings for a picture in a magazine, which was great.

When the **Rolling Stones** came along, they were exciting. I used to meet them in all the various clubs where John Lennon and the Beatles and everybody used to go, such as Scotch of Saint James, the Speakeasy, and the Revolution. If you were hanging around the pub scene in London at that time, you got to meet all the bands. Ian Stewart was on the scene with the **Stones** and did a little bit of playing here and there. Brian Jones and I used to go out drinking together. The first Indian meal I ever had was with Brian and Viv Prince on King's Road. Viv was the drummer of the Pretty Things, and to be honest, the **Stones** were quite influenced by the Pretty Things.

Ever since then, I've enjoyed the **Stones** and they've always put out good records. But I must say my favorite **Stones** music came from the period with Brian Jones and his 'sitar'. . . that was the real **Stones** sound. He also played the vibraphone and percussion instruments. The band had that Bo Diddley and Buddy Holly sound going, too.

The **Stones,** the Beatles and many of the other bands later became superstars, but in those days they weren't. Even though they were still accessible, we never took cameras into the clubs. Unlike today, where some photographers hide to take scandalous shots of someone and make a lot of money, in those days we had respect for the musicians, and we got respect from them. There was no money involved . . . we'd be happy to get a couple of sandwiches and a pint.

Jan
OLOFFSON

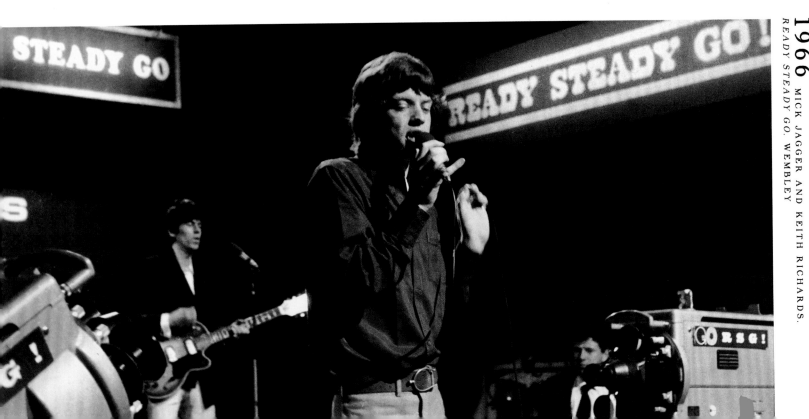

1966 MICK JAGGER AND KEITH RICHARDS. *READY STEADY GO.* WEMBLEY

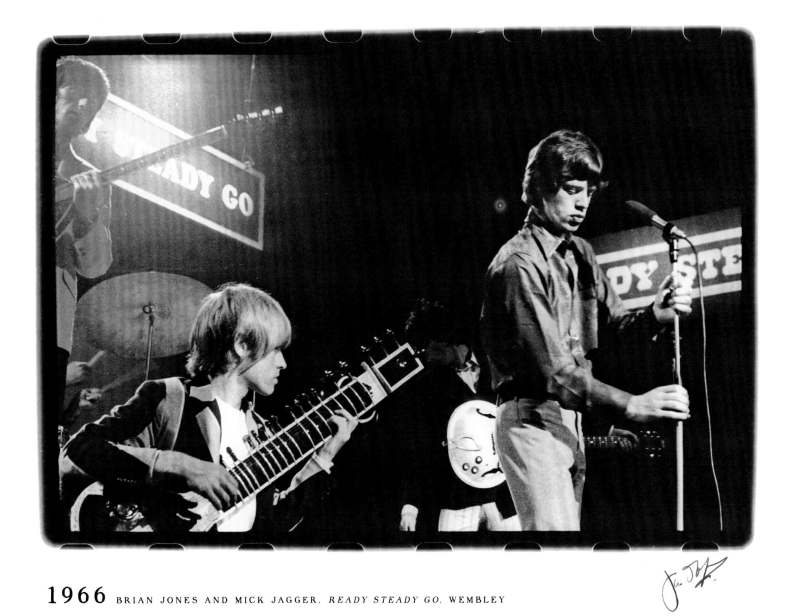

1966 BRIAN JONES AND MICK JAGGER. *READY STEADY GO.* WEMBLEY

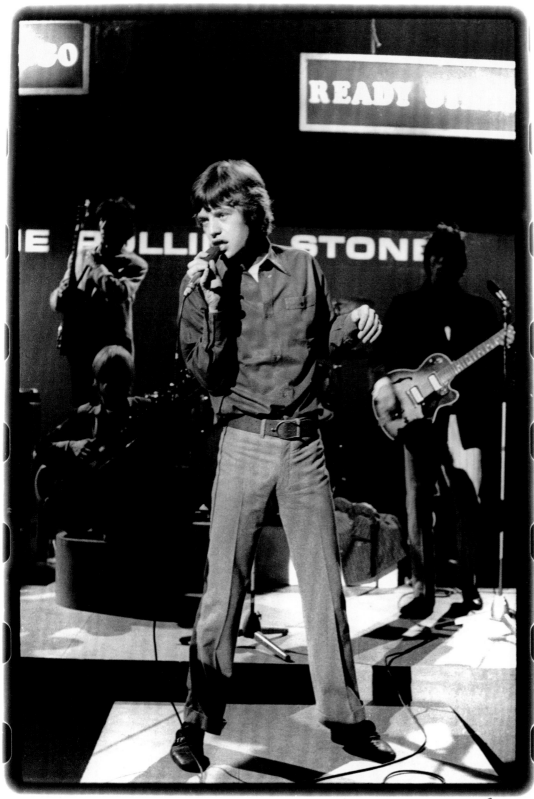

1966 MICK JAGGER.
READY STEADY GO. WEMBLEY

1966 KEITH RICHARDS AND BRIAN JONES. *READY STEADY GO.* WEMBLEY

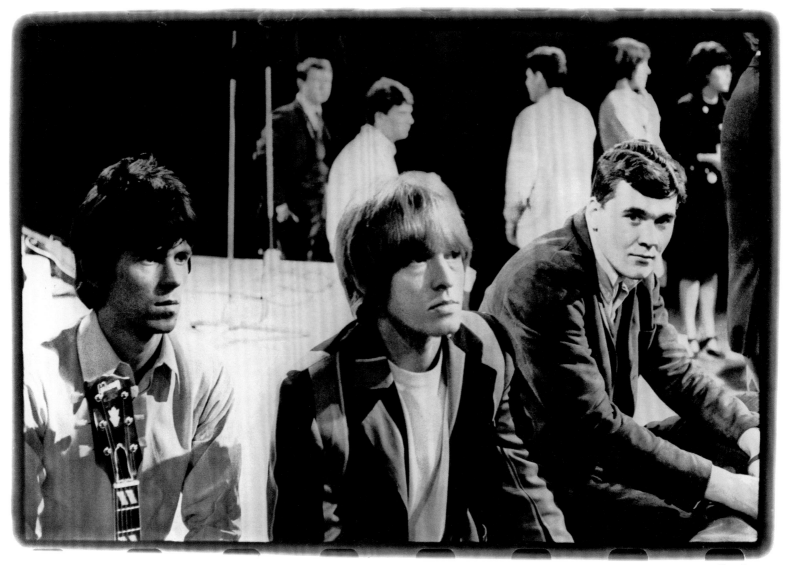

1967 BRIAN JONES. OLYMPIC STUDIOS. LONDON

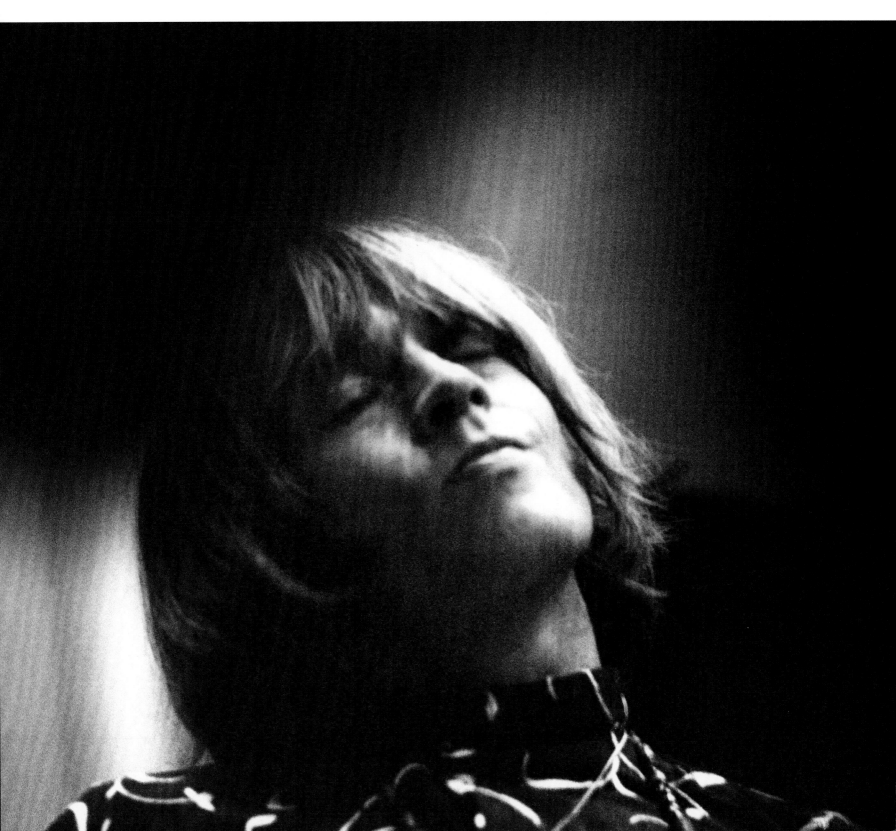

I photographed the Stones while working in the studio as an engineer from 1967 to 1968. Jimmy Miller was the first American producer to come over to England to work with Chris Blackwell's label, Island Records. Because of Jimmy's success with Traffic, which he and I produced together, the *Stones* approached him and, of course, he jumped at it. Jimmy was the producer for *Beggars Banquet* and I was his engineer.

Previously, when I worked with the *Stones* as an assistant with Glynn Johns, I couldn't take pictures, but as a senior engineer I could. I used to keep a camera on the console, sitting right next to me, loaded and ready to go. I'd snap pictures behind me, or run into the studio, shoot, and run back into the control room. My main function was engineering, but the camera was always there with me. I couldn't use the flash. Sometimes musicians would joke, "Kramer, get the fuck out of my face, you bastard." The bands got used to my being there with the camera and just ignored me. It became part of the furniture. My left hand would be on the console, my right hand would hold the camera, and I'd just swing around in my chair, click with one hand, swing back, and keep working.

I also did some live recording for them in Cleveland and some other places. I remember going on stage just before the show in Cleveland and tuning up Charlie's drums. He said, "Hey I never tune up my drums!" and I replied, "Yeah, I can tell." Ian Stewart was an absolutely unflappable guy and a wonderful keyboard player. He was their roadie, and drove them around in a VW bus when they first started. They used to hide him on stage.

Brian was the unsung hero of the *Stones*, and the most creative. He would take chances with different instruments and musical cultures and try to incorporate them into the *Stones'* music. He was a great guy, and a very close friend of Jimi Hendrix. Brian absolutely revered Jimi, and Jimi really liked him. I love my photographs of Brian with his head back and the light shining. He looks almost angelic.

On November 27, 1969, Jimi's birthday, I photographed the *Stones* at Madison Square Garden. Jimi said, "Come with me, let's go up and hang out at the Garden." We went backstage and Jimi sat down with Mick, Charlie, and Ian. How could you resist taking that picture?

Eddie
KRAMER

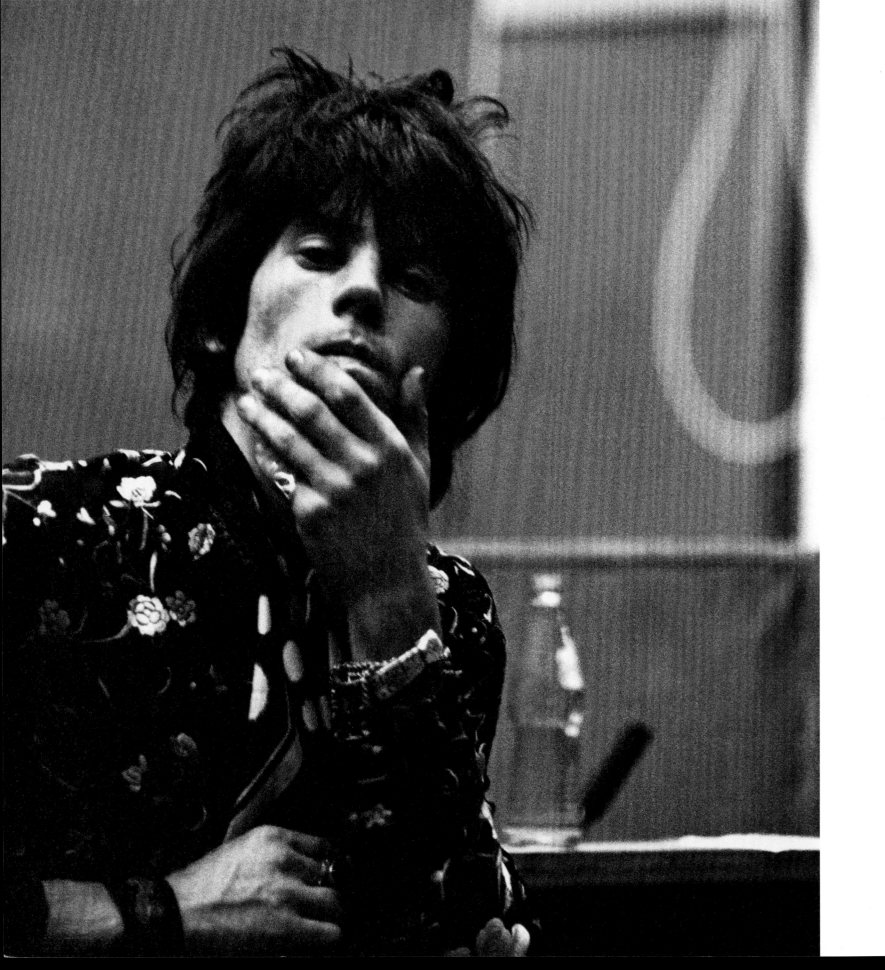

1967 KEITH RICHARDS. OLYMPIC STUDIOS. LONDON

1969 JIMI HENDRIX AND MICK JAGGER,
MADISON SQUARE GARDEN, NEW YORK

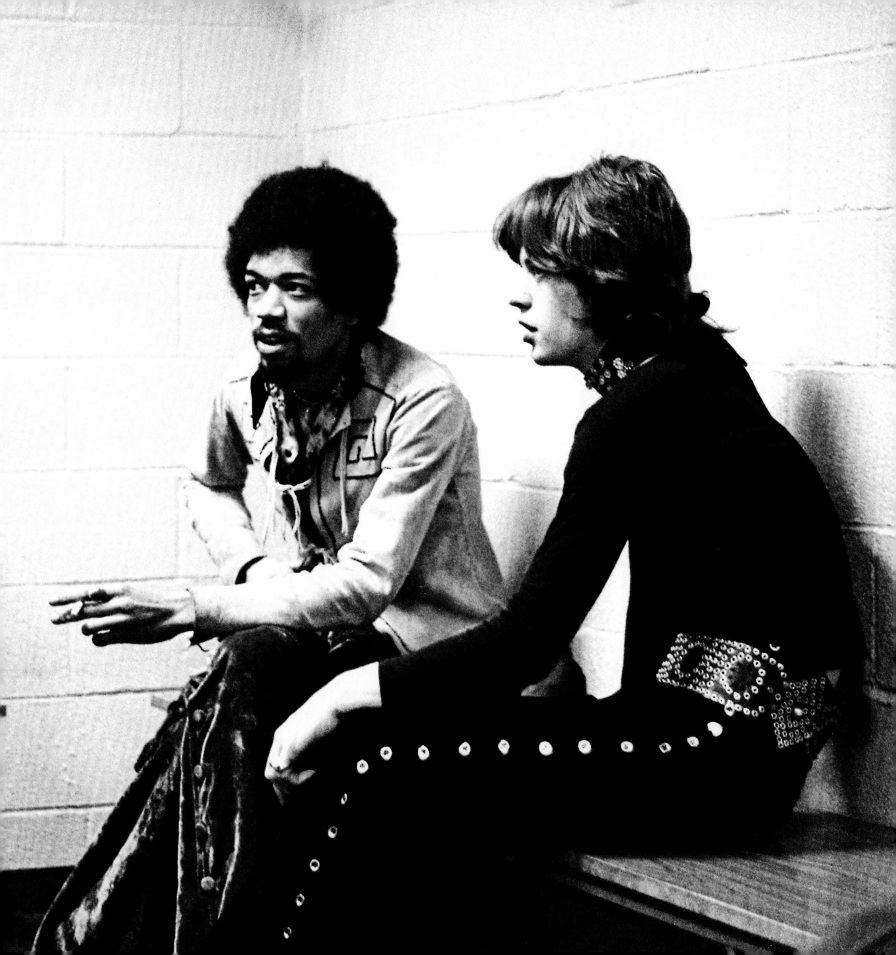

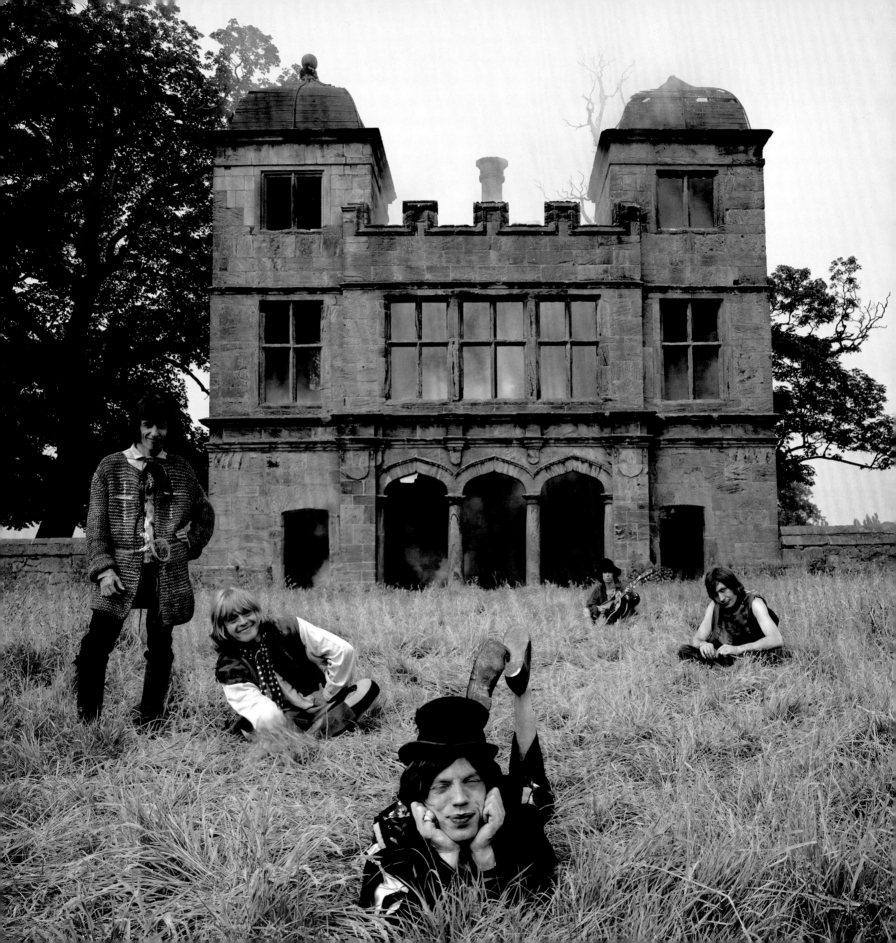

I *had just survived* a few months in Vietnam covering the war for *Town* (England's answer to *Esquire*) and had shot numerous White Horse Whiskey ads. The latter taught me the trick of handling animals by using a megaphone to create unusual sounds. This helped me coordinate a hungry goat, a dopey sheep, two dogs (one stuffed), and a cat, in addition to the semi-stoned *Stones* at eleven A.M. in a Victorian Society Painters Studio in Hampstead, London.

The location was a medieval jousting pavilion, which was a great backdrop with the help of many smoke bombs. Afterward, the *Stones* changed into cricket gear for the back cover image, with a two-legged piano as an added prop.

Handling the *Stones* was easier than the animals. They were all in a state of shock from a police raid on Brian Jones' flat the day before ... and the megaphone is mightier than the sword. Keith was the most cooperative, so my image of Keith and the Boston Terrier with Mick leering in the background is my favorite image.

The assignment was to shoot on 10x8 color, which is slow to record and notoriously difficult to realize depth of field. As a safety, I shot a couple of rolls of Ektrachrome 200 and some black-and-white film on a Hasselblad super-wide, which I developed and printed overnight. I wanted to show Mick my Kodalith prints so that they would sign some for me. During a tea break in Chester (Derbyshire), I presented some color prints, as well as the Kodalith prints. Mick was knocked out by the richness and depth of the Kodaliths and he immediately signed and dedicated the portrait to me—my unique trophy from a momentous shoot.

Mick was so delighted with the Kodaliths, he decided to elbow the color. Luckily, some were used for the American sleeve. He had the orgy scene hand-colored, which gave the provocative image an even more bizarre, Bunuel-ish look.

1968 THE ROLLING STONES, BEGGARS BANQUET, DERBYSHIRE

Michael
J O S E P H

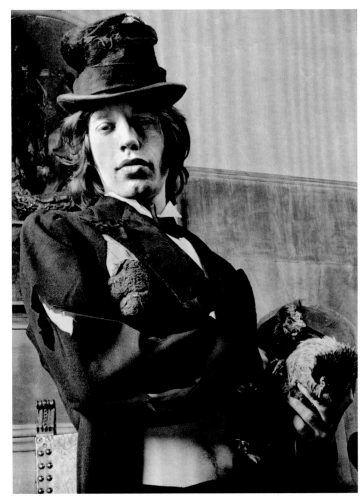

1968 MICK JAGGER, *BEGGARS BANQUET*, LONDON

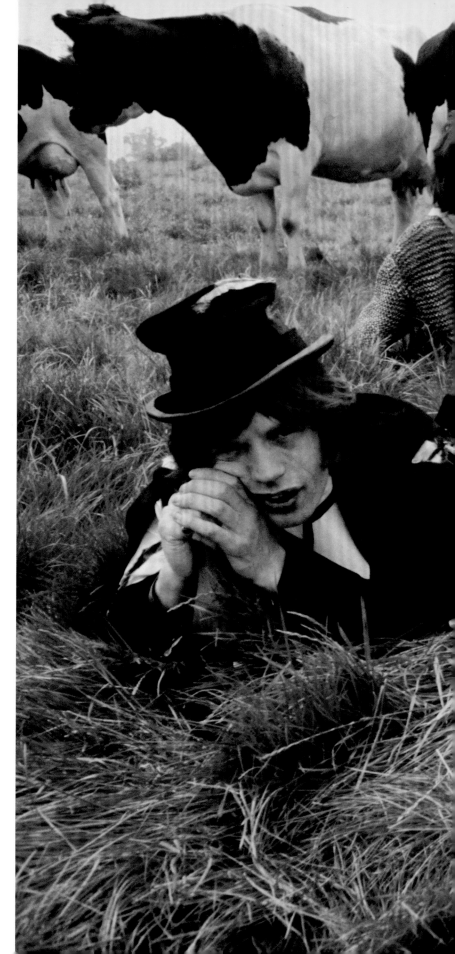

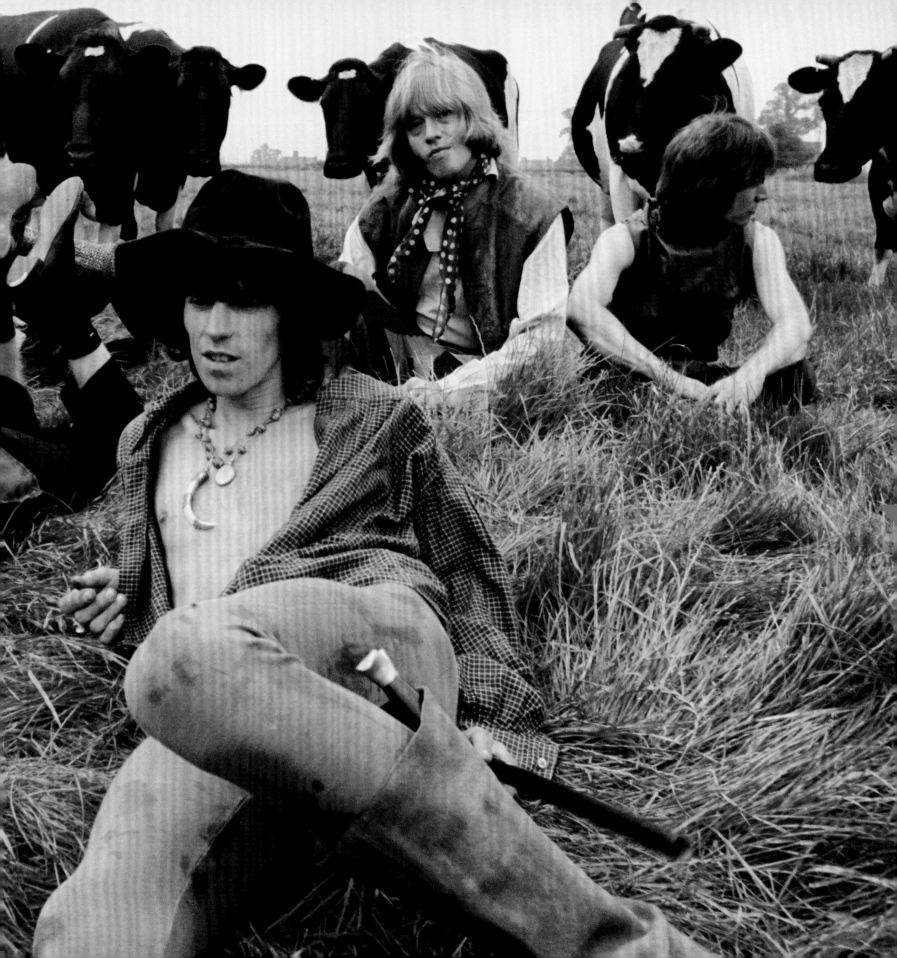

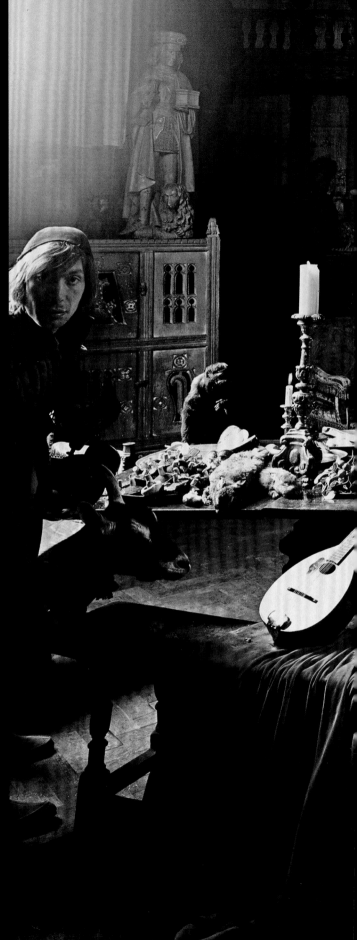

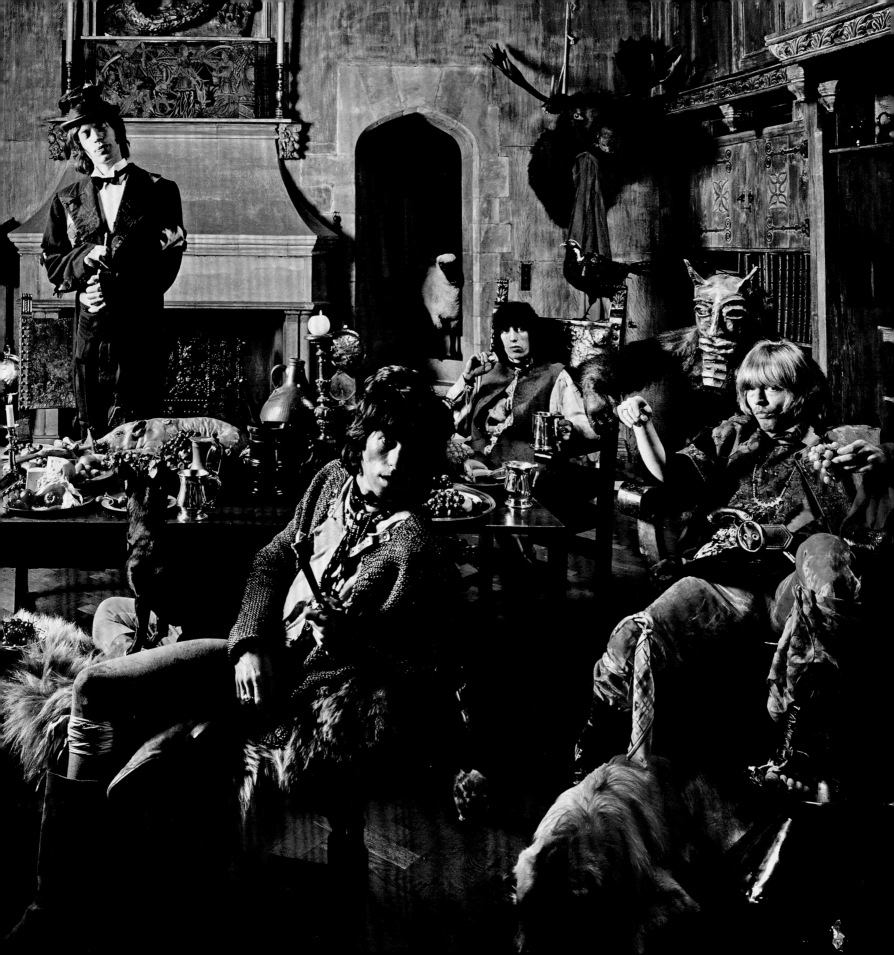

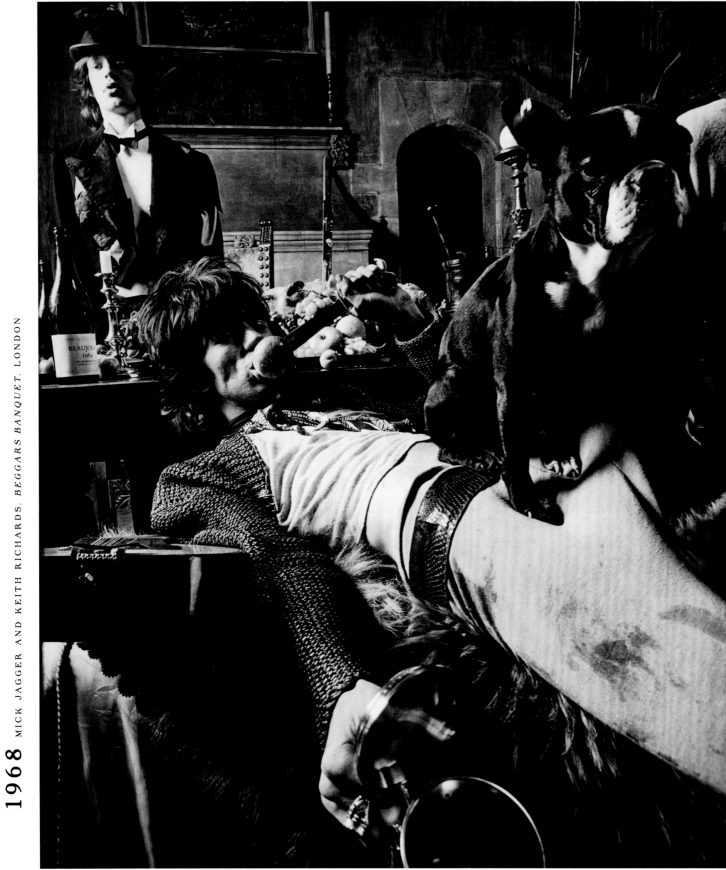

1968 MICK JAGGER AND KEITH RICHARDS. *BEGGARS BANQUET.* LONDON

BEGGARS BANQUET. FRONT AND BACK COVERS NEXT PAGE

Mick called and said, "We have something called **Beggars Banquet,"** and he asked us to do the photos. Tom Brooks and I agreed to do it. I went over to my Porsche mechanic on Cahuenga Boulevard because I remembered that he had a funky fucking bathroom. I said, "Let's put the **Rolling Stones** on the wall." Mick and Keith came over and we put all kinds of shit on the walls, right in Hollywood. Tom wrote on there; my name's on there. I also wrote a poem to my wife. If you look really carefully, you'll see a cock with two balls.

Barry
FEINSTEIN

That created a controversy. One of the directors wouldn't put the album out when they saw it and held it up for six months. It was published in *Time* and was supposed to be the cover for the whole thing, but they did the white LP instead. Years later when they put the CD out, they used our shots for the front and back covers.

I know we were having fun, how could we not? That's just how it works. Allen Kline was managing them. *I don't think I ever got paid for those shots.*

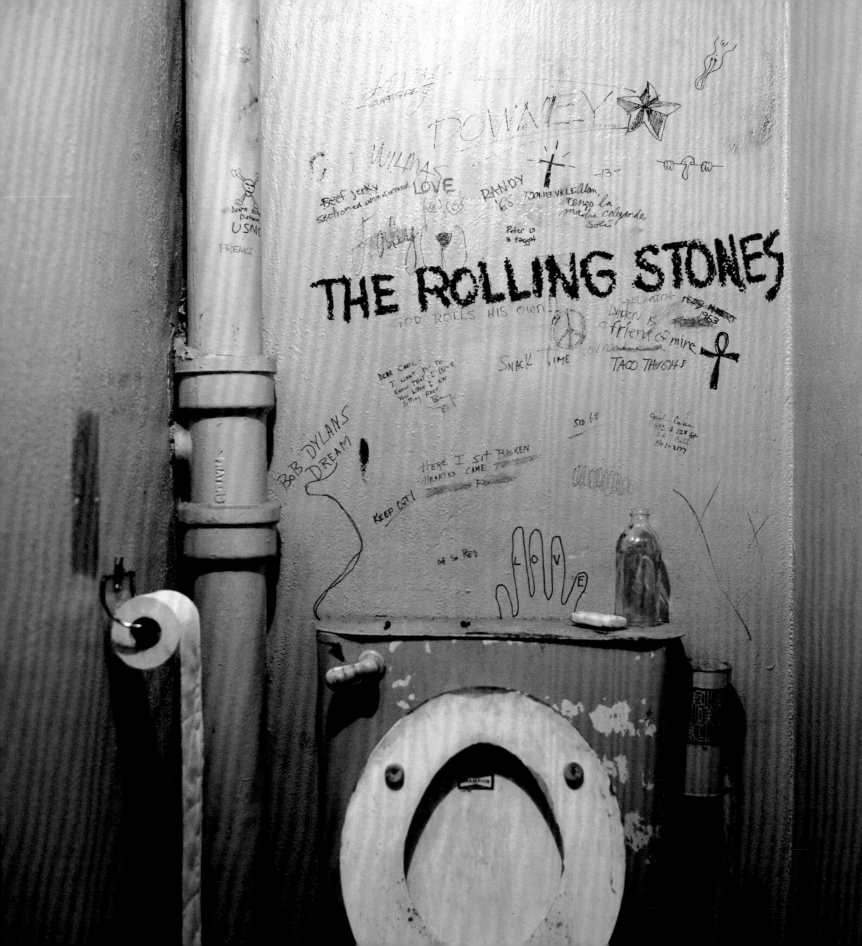

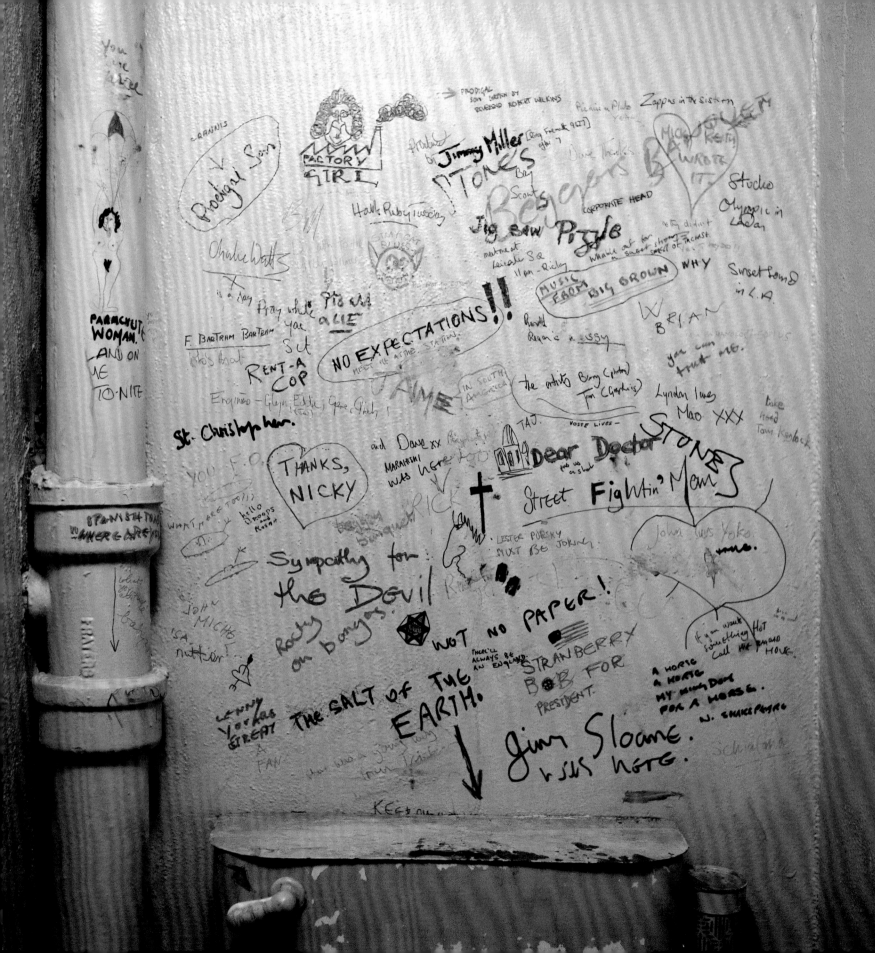

Baron WOLMAN

The first shots *I did of the* Stones *were of Mick on the set of the film* Performance *in 1968,* when I was the chief photographer for *Rolling Stone* magazine. The shoot took place in the studio in London and, as you can see, Mick was very heavily made up. I love that photo; it was an incredibly memorable time. That same week, I shot George Harrison at Apple and the Who recording *Tommy.*

I took my first live shots of the Stones in 1969 at the Oakland Coliseum. I was so excited that I wasn't checking my equipment all the time and my lens wasn't locked into the camera. Many of the shots were out of focus. For the show in 1978, I was the only photographer allowed on stage because I was close to Bill Graham, the producer of that show. I shot from in front of and behind the stage. I had access, the kind you wouldn't see now. That's the reason I got out of rock 'n' roll photography. The late 1970s was the last time responsible and professional photographers had the freedom to get the great shots. Now, once you get all of the security clearances, you have to sign away your firstborn just to get the shoot, not even to get on stage. Rock 'n' roll photographers have been relegated to slave labor, the third-class citizen. When access is denied or limited, it's like having your balls cut off. You become a photographer-eunuch.

The *Stones* are the ultimate rock 'n' roll band. Every time you go to a show, you get so energized you have to dance right in your seat.

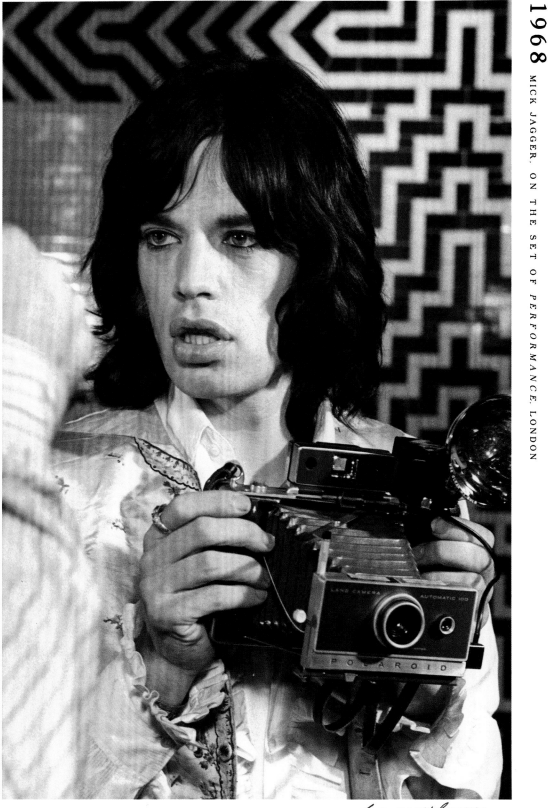

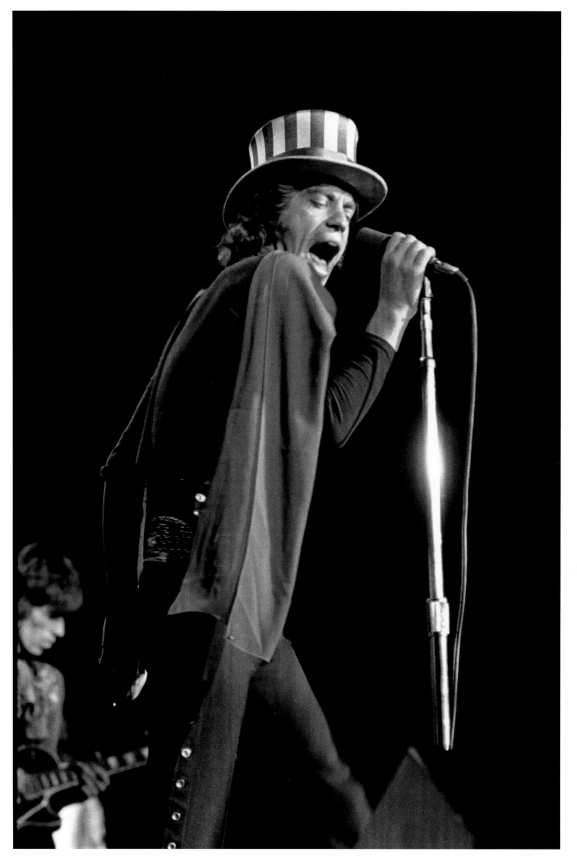

1969 MICK JAGGER, OAKLAND

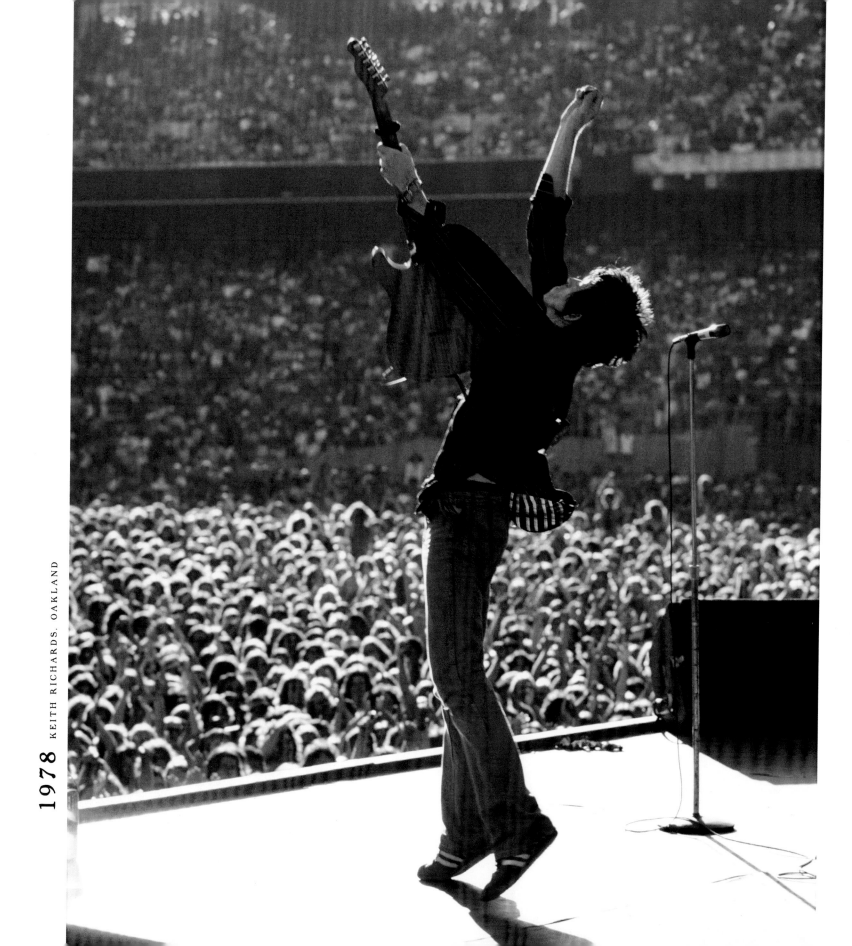

Michael
C O O P E R
Text by his son, Adam Cooper

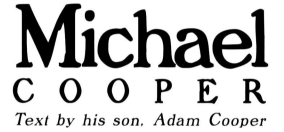

Michael came to shoot the Stones through their mutual friend Robert Fraser. Dad hit it off with the band and became particularly close friends with Keith. The rest is history.

For the *Satanic Majesties* cover, the **Stones** came up with the idea of producing these acrylic movable discs so that the heads of the band members moved depending on how you angled the album cover itself. The only place in the world that could do that was a studio in New York. They went off to New York, and that's why you have those shots of the band outside buying all the clothing and the stuff to build the set. Those images are still amazing. Can you imagine Mick Jagger going out there now and sticking things on the set and building the whole thing himself? They shot that session there and the result was incredible. I think it was Allen Kline who got the bill estimating the cost to mass distribute this new effect, and he threw it straight out the window. He said, "Forget it, it's just going to cost too much." Production of the special cover was limited to the first five hundred or so, and the rest were just a straight print run of the image itself. I still have an album cover with the plastic acrylic and the moving heads.

During the '60s, Michael and Keith were great buddies. Lots of people said they used to look like each other, so it was like the terrible twins on King's Road every day. They really hit it off, for all the good reasons . . . and all the wrong reasons.

In the early days, Michael was working principally through *Vogue*. Back then, you were told what to shoot, where to shoot, how many rolls to shoot, and when to deliver the work. Michael got very frustrated with the restrictions of fashion photography. That's why he got out of it as quickly as possible, and that's why he enjoyed shooting the **Stones**. The images make absolutely clear that Michael's stuff is really "fly on the wall." It's not constructed and the light is entirely natural. The strength of his work lies in great composition and grabbing the moment when it happens, which is really difficult to do. You have a second to do it, and if you ask the subject to do it again, the effort becomes posed. The *Satanic Majesties* and *Sergeant Pepper* covers were about a group of buddies sitting around and coming up with this really weird and wonderful idea. I know Michael would be extremely proud today of having done the *Satanic Majesties* and *Sergeant Pepper* covers.

Michael's talent came from an obsession for photography and living with the camera twenty-four hours a day. No matter what state he was in, he managed to find himself at the right place at the right time to capture magnificent images.

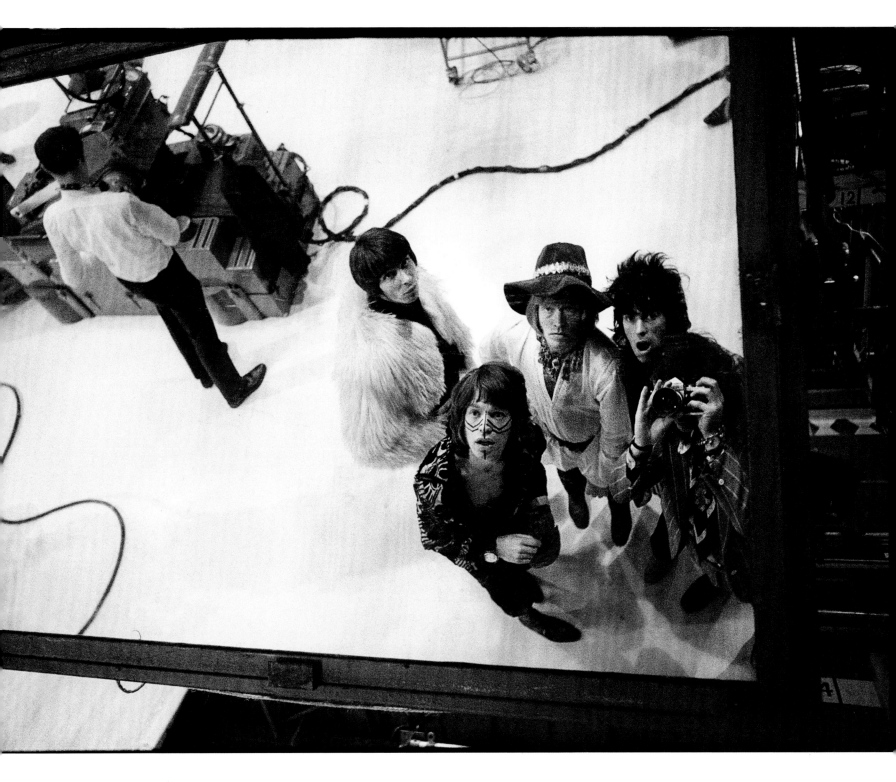

1967 CECIL BEATON SNAPS KEITH RICHARDS, MARRAKESH

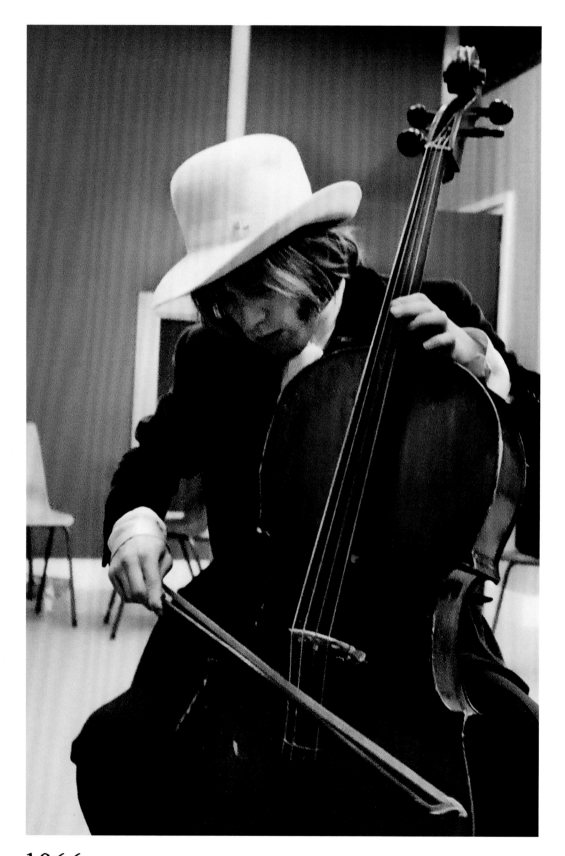

1966 BRIAN JONES, MONTEREY INTERNATIONAL
POP MUSIC FESTIVAL, CALIFORNIA

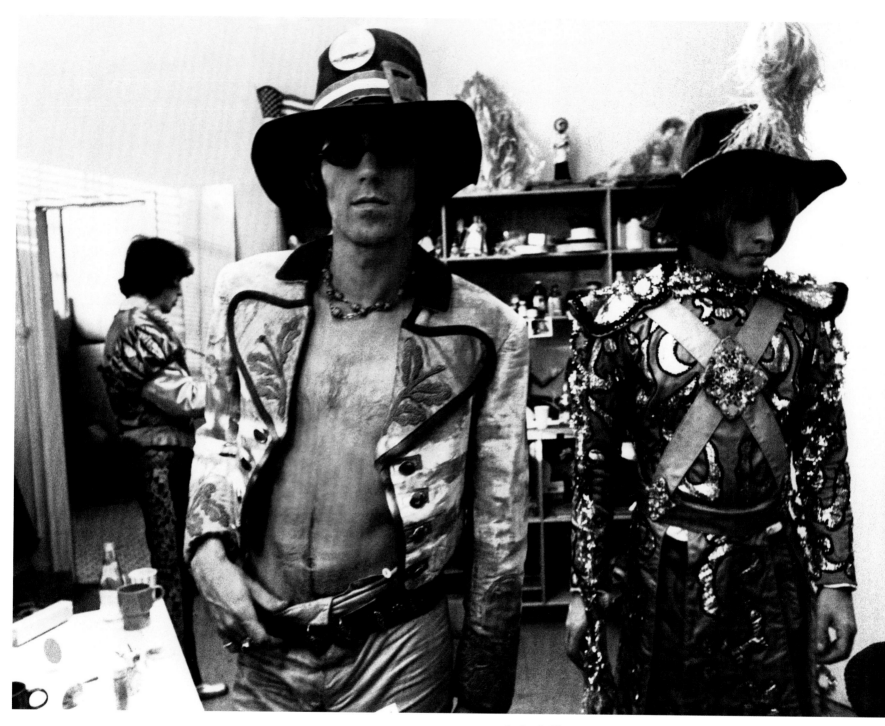

1967 KEITH RICHARDS AND BRIAN JONES.
SATANIC MAJESTIES PHOTO SESSION. NEW YORK

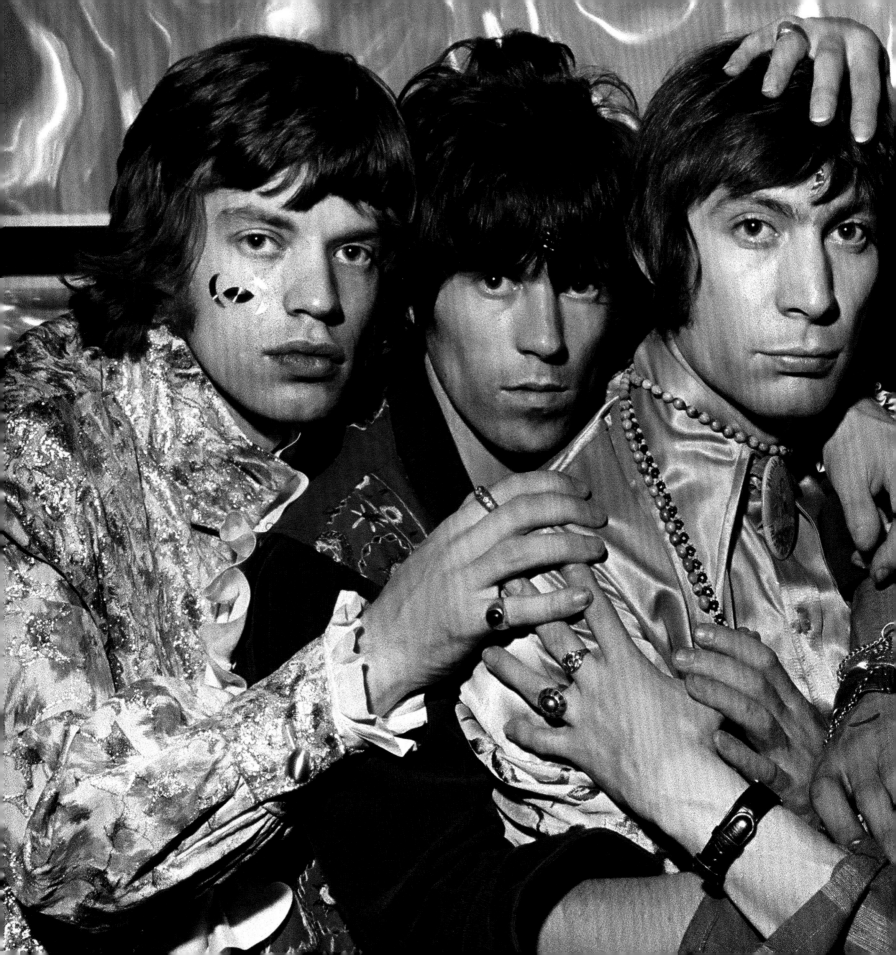

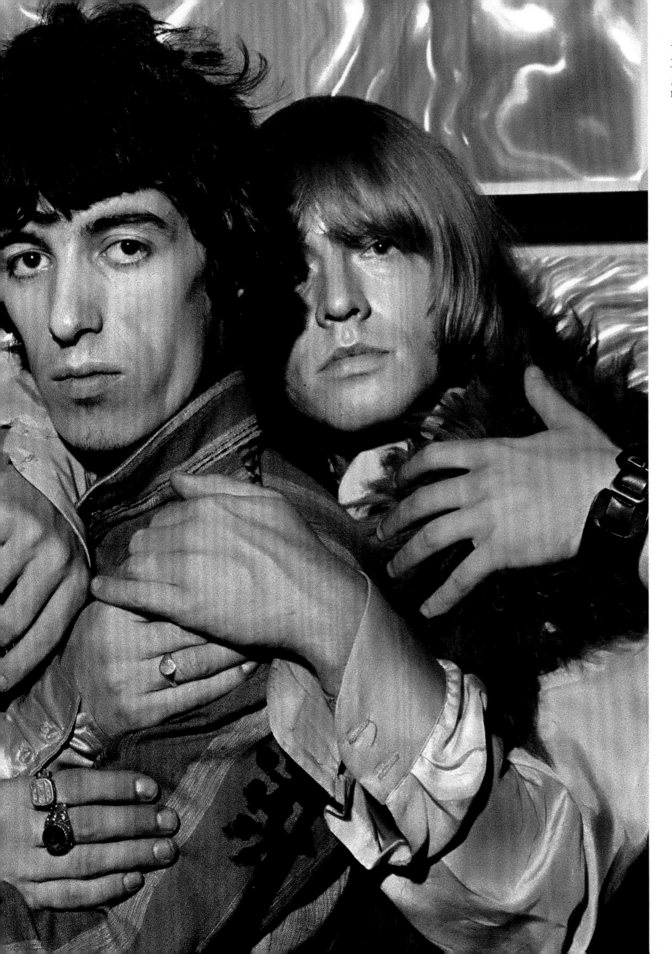

1967 THE ROLLING STONES.
"ELEVEN HANDS." *SATANIC
MAJESTIES* PHOTO SESSION.
NEW YORK

1968 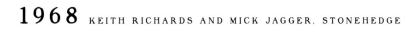 KEITH RICHARDS AND MICK JAGGER. STONEHEDGE

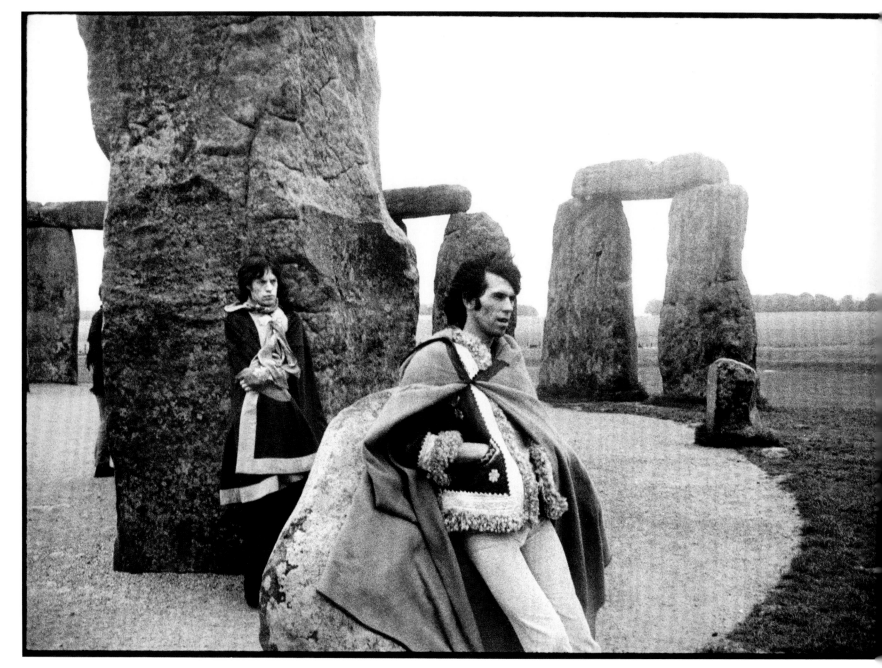

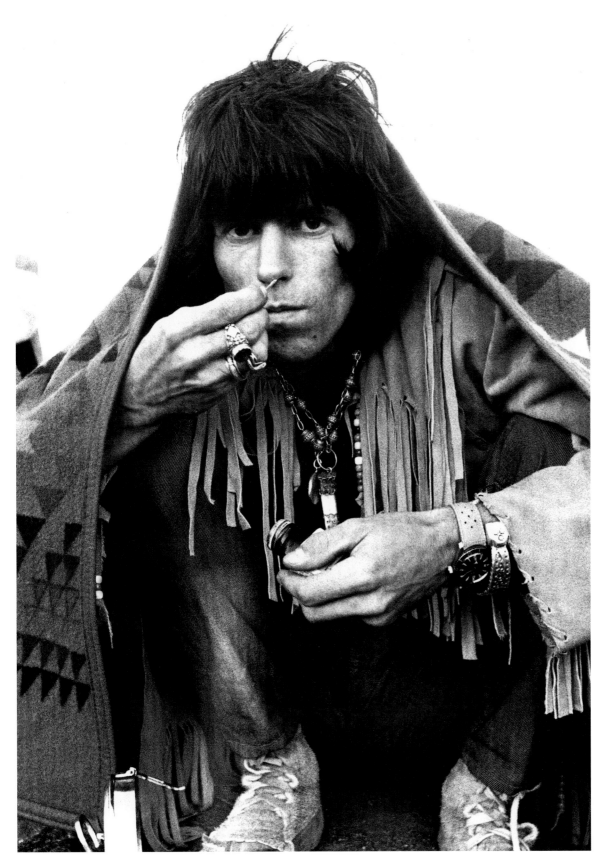

1968 KEITH RICHARDS.
JOSHUA TREE. CALIFORNIA

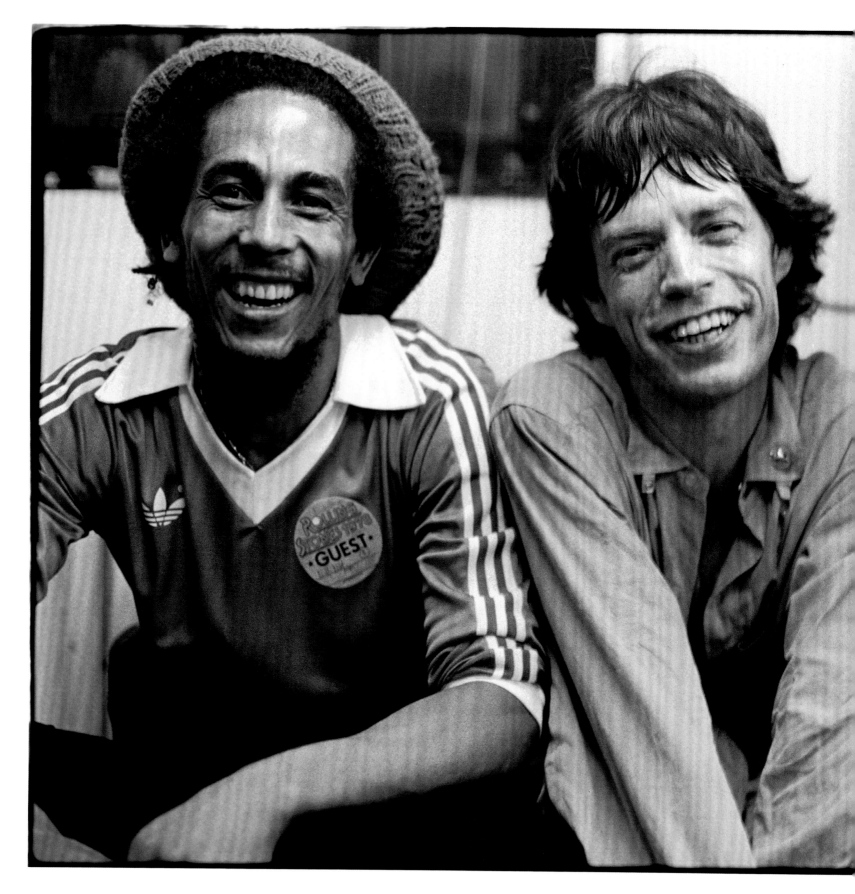

NYC '78

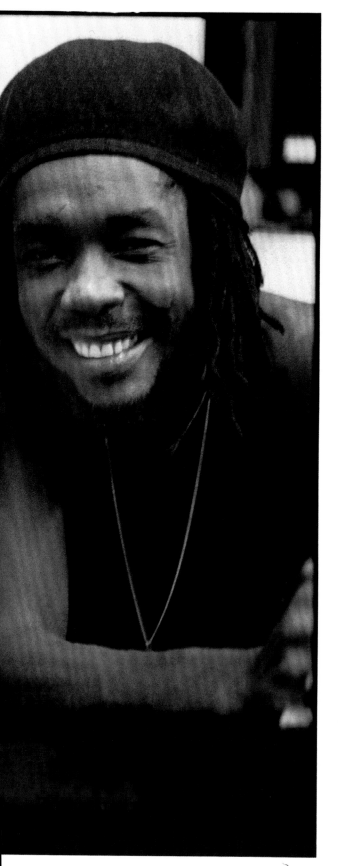

Michael Putland

***A**side from the fact that shooting the **Stones** was great for my career as a photographer,* I've always loved the band. I've been watching the **Stones** live since 1964. I came out of that whole R&B/jazz thing that the **Stones** and everybody came out of. While I was living in the northwest part of London, which is the equivalent of Queens, I saw them on a packaged show with the Ronettes and the Everly Brothers. It was amazing.

In 1972, I had a studio with a friend who was bankrolling me, but I couldn't get any work. I finally told him I was going to quit, get a job, and pay him back. We went out and got drunk. The next morning I went back to the studio to clear up my stuff when a phone call came from *Disc and Music Echo*, a pop magazine. Judy, the editor's

Michael
P U T L A N D

assistant, asked if I would do a shoot for them that day, and I replied, "Actually, Judy, I'm quitting today. I'm giving up." "Well I think you might want to do this," she said. The assignment that saved my career was Mick ... just out of the blue. After that, I began photographing everyone for that magazine every week. I shot him again on the train to Cardiff Castle in 1973. Then I did the European tour that same year.

They were all good-looking, photogenic guys in their own way. Charlie and, of course, Ronnie were brilliant and so was Mick Taylor when he was there. Obviously, Mick and Keith were fantastic to shoot. In all my contacts with Mick, in those days I found him a bit intimidating, although he's a very fair, terrific guy. Keith in those days was a little distant but he's always been great. And Bill—he'll kill me for saying this—maybe he wasn't the most photogenic, but he had a booty sort of look. He was the one who got all the girls anyway.

1978 BOB MARLEY, MICK JAGGER, AND PETER TOSH, PALLADIUM THEATRE, NEW YORK

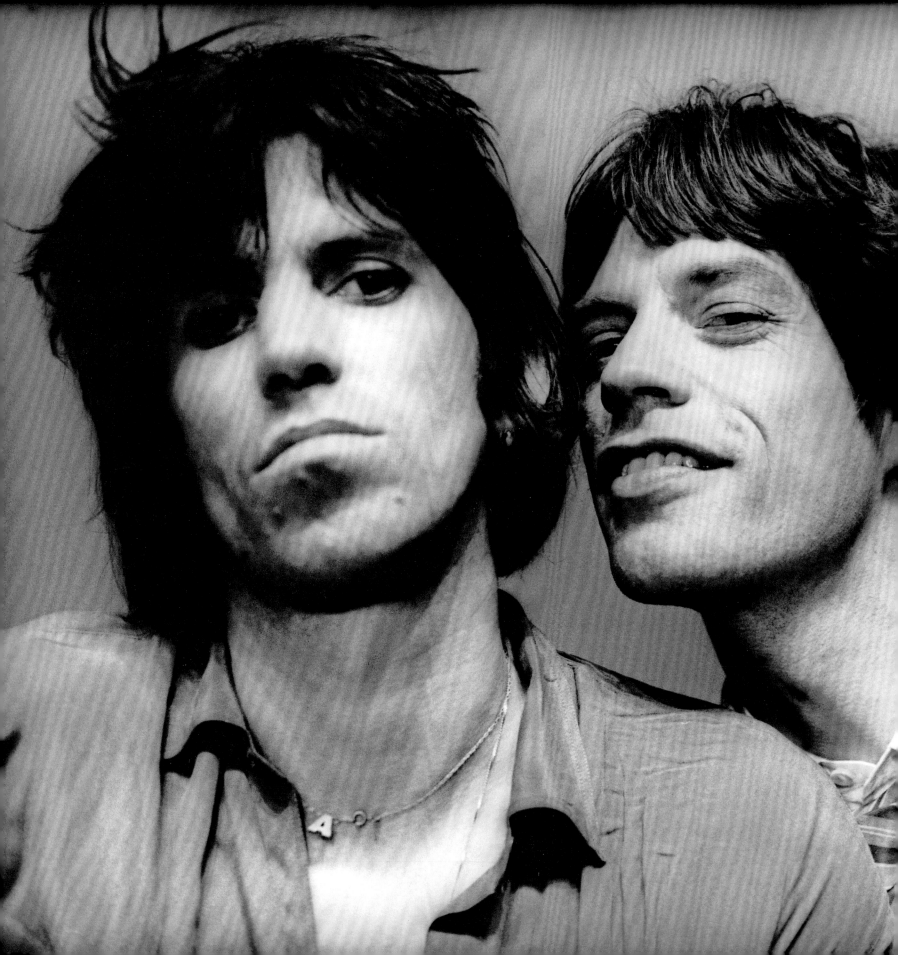

1978 KEITH RICHARDS AND MICK JAGGER, NEW YORK

1973 MICK JAGGER, MUNICH

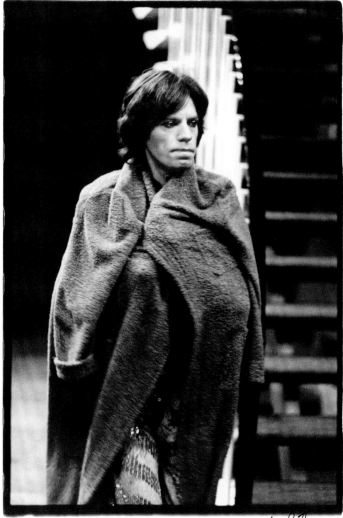

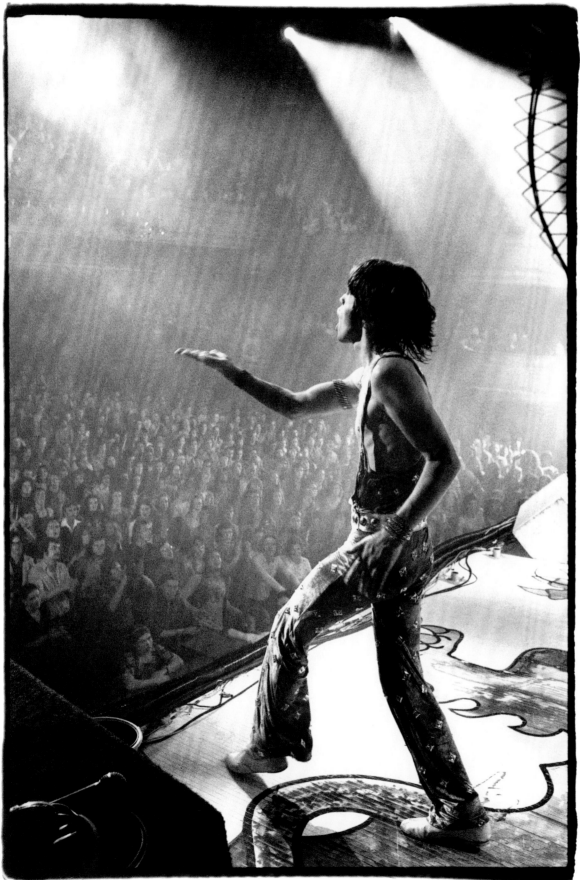

1973 MICK JAGGER.
APOLLO. GLASGOW

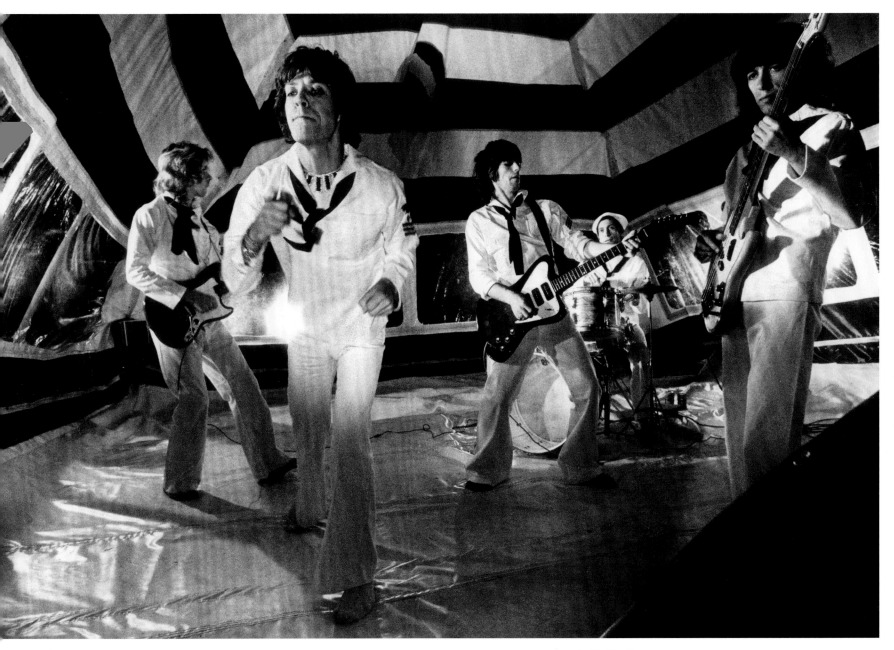

1974 THE ROLLING STONES,
"IT'S ONLY ROCK AND ROLL" VIDEO, LONDON

Bob
GRUEN

I was a huge Stones fan. In 1964 or 1965, I ran into a friend of mine on 14th Street who was scalping tickets for a concert. The **Stones** were the first band I ever saw in concert, and it totally blew me away. Until then, I had seen bands only in bars. I saw them again in 1969 with Tina Turner. My first assignment to photograph them came in 1972 through Lisa Robinson, then editor of several magazines including *Rock Scene*. Over the years, I got to do some of the **Stones'** events around New York, including a lot of press conferences.

The photograph of Mick and Andy Warhol, who did the cover of the *Love You Live* album, was taken at Trax nightclub. They were signing autographs at a press event for the record release party. The band was very accessible that day, meeting with the press, going from one table to another talking to people, laughing it up, having drinks, and signing anything people brought with them. I think they had tablecloths that matched the record, and Mick was signing those too. Mick and Andy were obviously comfortable with each other and knew each other very well by then.

Mick's great because he's very expressive and moves a lot. There isn't one pose and you've got the whole thing. He changes every second and you have to keep chasing him around the stage. He actually moves so fast it's hard to get a clear shot.

You can't take a bad picture of Keith. Keith is just so cool. With other people, the eyes are drooping or the mouth is slack, and you would never use it. But with him, every shot is killer because he is so charismatic. He was pretty drugged out in the '70s, but he seemed to be waking up in the '80s. By the time of his solo albums, we started to see another side to Keith. The concerts would start in the dark, and the band would come out and have a meditative moment before playing. Very often, he would drop to his knees as if to thank some spiritual guide for seeing him through. That photograph captures a more spiritual Keith, rather than the typical "out of it" Keith.

When I shoot the **Stones,** I sing along as I do it, because I'm such a fan. But it's hard work, and you have to stay alert because you get a photo pass for a few minutes only. You have to shoot so much film so fast. People ask what songs they did, but I don't remember. I'm just so busy shooting.

Looking at my pictures, they seem to talk to me and take me right back to being there. I can practically hear and smell those times. I like those memories. I had fun and have fun looking back at it.

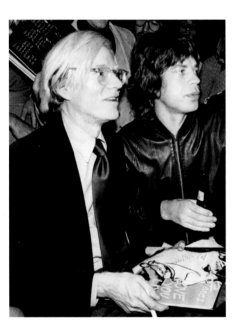

1977 ANDY WARHOL AND MICK JAGGER, NEW YORK

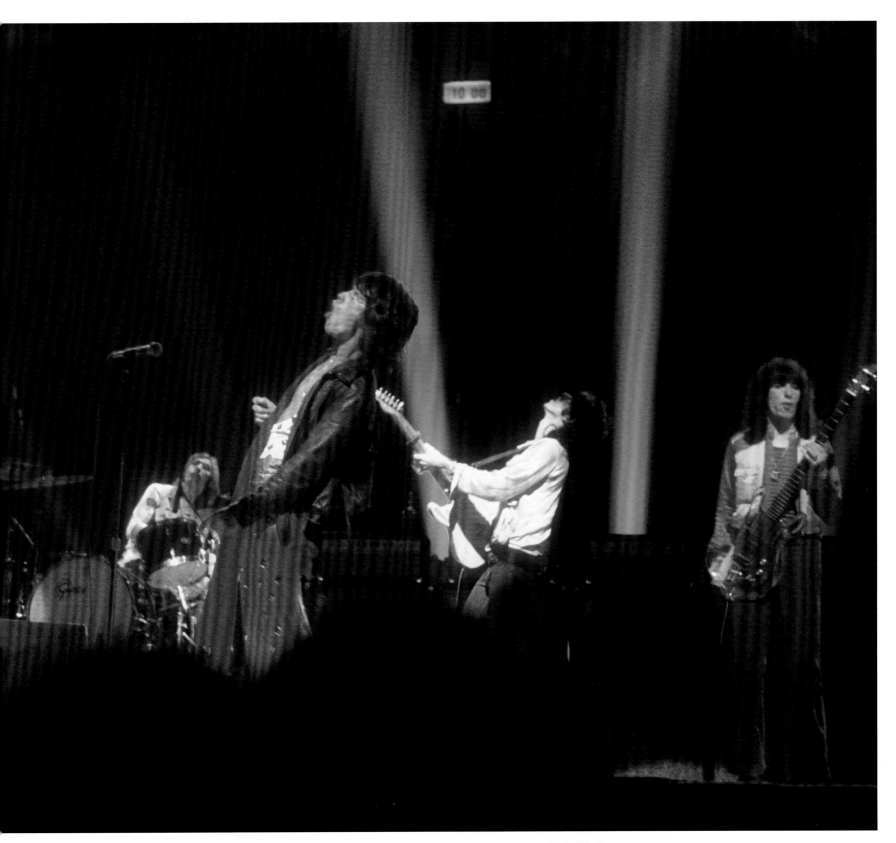

1972 MADISON SQUARE GARDENS. NEW YORK

1993 KEITH RICHARDS, THE BEACON THEATRE, NEW YORK

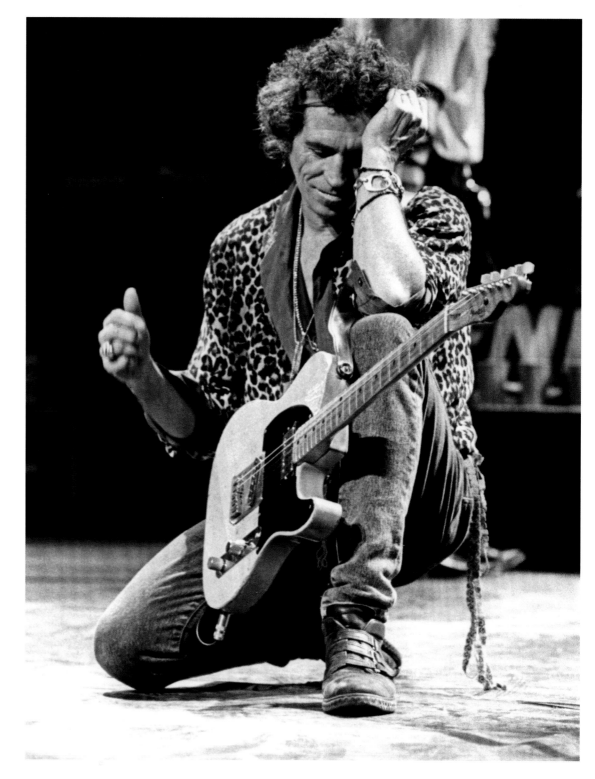

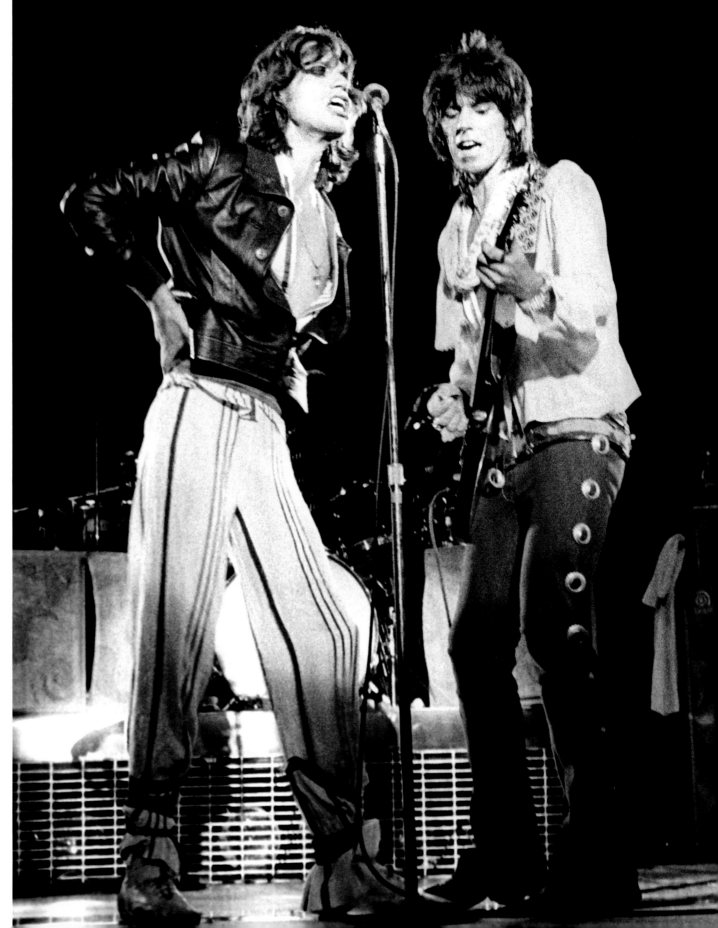

MICK JAGGER AND KEITH RICHARDS, BATON ROUGE, LOUISIANA

Mark
WEISS

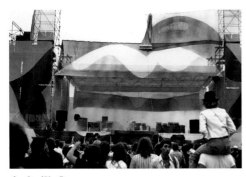

1978 JFK STADIUM, PHILADELPHIA

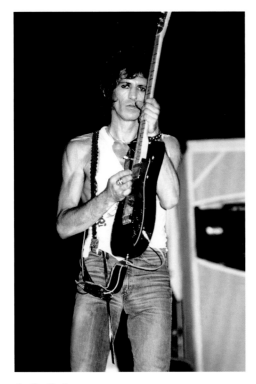

1981 KEITH RICHARDS,
HARTFORD, CONNECTICUT

Mark Weiss is an American rock 'n' roll

photographer. Thirty years ago he began shooting covers and features for major rock magazines, such as *Circus, Rolling Stone, Creem, Hit Parader, Faces,* and *Rock Scene.* Since those early days Mark has been on the road capturing some of rock 'n' roll's biggest icons on stage and behind the scenes. He has shot numerous album covers, including Twisted Sister's *Stay Hungry* and Bon Jovi's *Slippery When Wet.*

In 1973, when he was fourteen years old, Mark made a deal to cut his neighbor's lawn all summer in exchange for a 35mm camera. While in high school, Mark snuck his camera into concerts, making his way close to the stage to shoot. He developed the prints in his parents' bathroom and sold them for a dollar each. In 1977 Mark was arrested for selling his photos outside of a Kiss concert at Madison Square Garden in New York City and spent the night in jail. The next day he walked into the offices of *Circus* magazine with his portfolio. The timing was perfect. The art director needed Aerosmith pictures, and soon thereafter Mark was hired as staff photographer.

Nineteen-year-old Mark photographed his first **Rolling Stones** concert on June 17, 1978, at Philadelphia's JFK stadium. Without a photo pass, Mark still had to sneak his cameras into the concerts; he slept outside the stadium the night before to get close to the stage.

After the Stones finished their set, rowdy, unhappy concertgoers began throwing anything and everything onto the stage, which was shaped like the band's famous "tongue" logo. Mark says of that event, "The fans wanted more. They expected the **Stones** from the spectacular '75 tour, where they performed all their classics. This time they played a lot of new songs, fewer classics, and a shorter, 'no frills' set. I didn't see any flames, just smoke. I felt the unpredictability of the crowd, and I wanted the chance to capture it with my camera. A chance to document something out of the norm and maybe a bit of rock 'n' roll history," as damage to the stage was estimated at a million dollars.

On April 22, 1979, Mark's assignment was to shoot the New Barbarians at the Oshawa Civic Auditorium near Toronto. The concert was a charity benefit fulfilling one of the conditions of Keith Richards' 1978 sentence for possession of heroin. Keith looked great and seemed happy to be free to play with his bandmate Ronnie Wood.

Two years later, on September 25, 1981, Mark arrived for the first show of the **Stones**' sixth U.S. tour, again at JFK stadium; this time he had a coveted photo pass. "I was actually hired to shoot backstage shots of Journey, who were opening the show along with George Thorogood, so it was exciting to be there with all-access," he says. "This time I was finally on the other side of the barricade, in the pit, shooting the biggest band in the world! This show was the **Stones** we wanted—a rock 'n' roll extravaganza—a huge colorful stage and Mick throwing roses off a cherry picker. It didn't get better than this!"

Mark photographed the Stones in Hartford, Connecticut, and at Madison Square Garden during the same tour in November of '81. "The Garden show was especially cool for me—it was my first **Rolling Stones** assignment for *Circus* magazine." As Weiss says, "I belonged there and was legit . . . and it sure beat jail!"

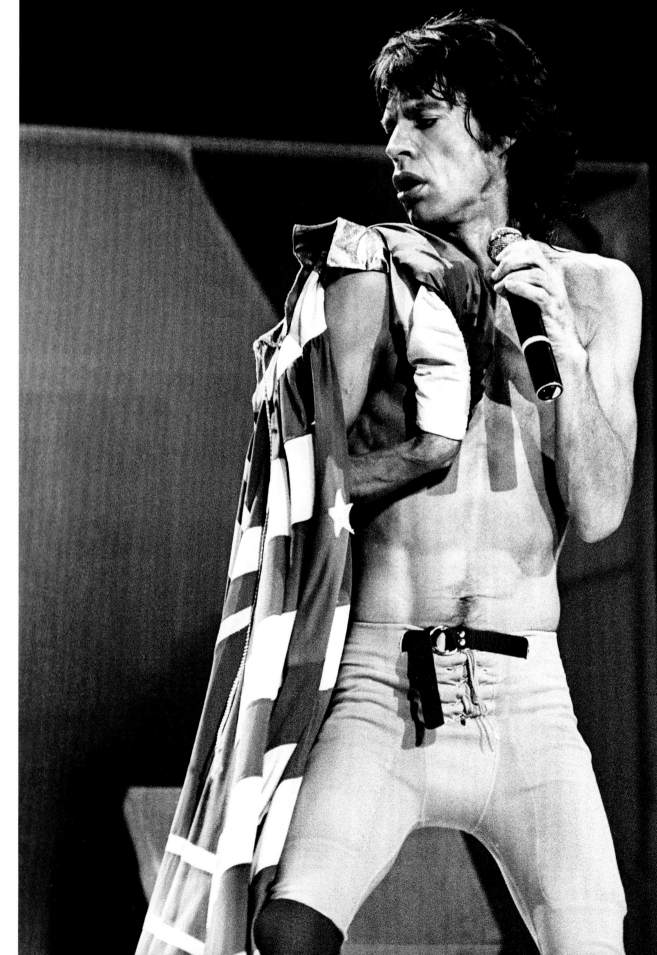

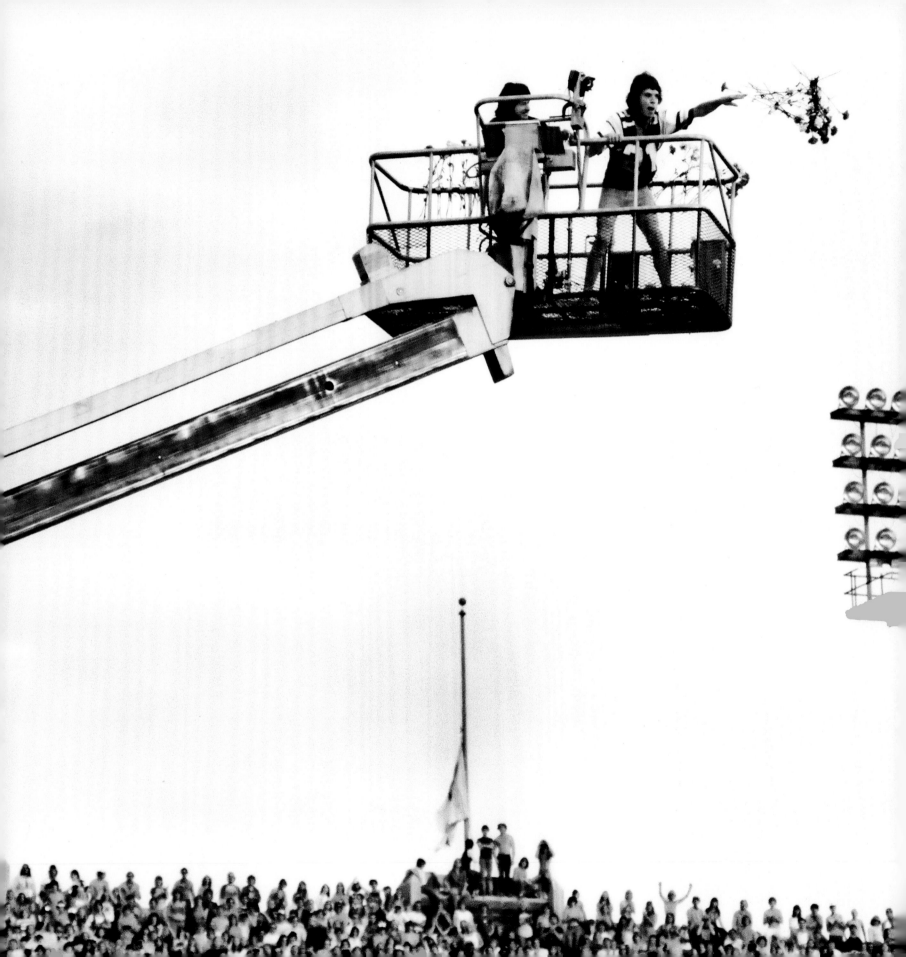

1981 JFK STADIUM. PHILADELPHIA

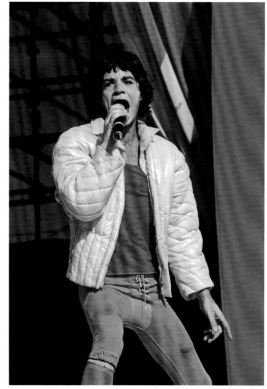

1981 MICK JAGGER. JFK STADIUM. PHILADELPHIA

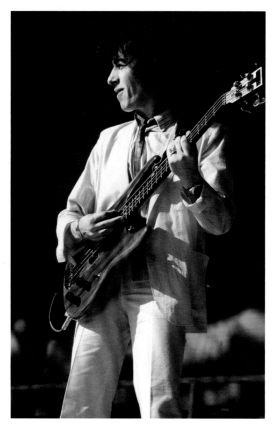

1981 BILL WYMAN. JFK STADIUM. PHILADELPHIA

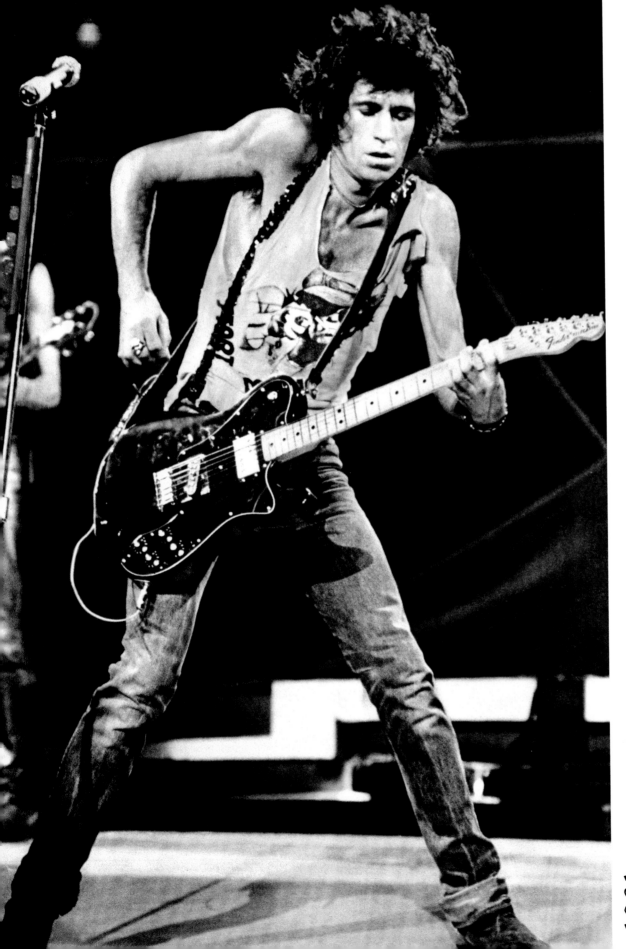

1981 KEITH RICHARDS, HARTFORD, CONNECTICUT

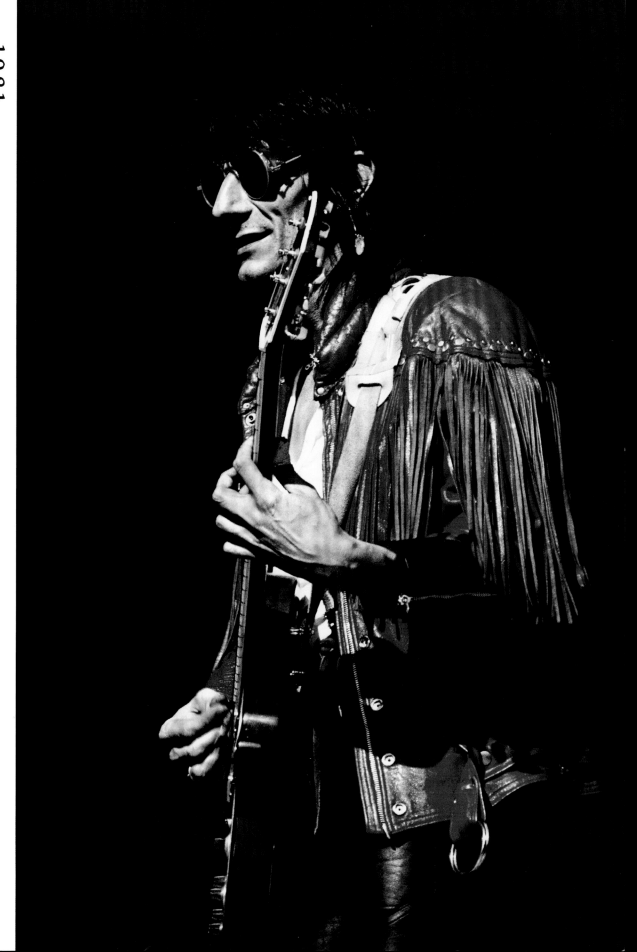

1981 RON WOOD. JFK STADIUM. PHILADELPHIA

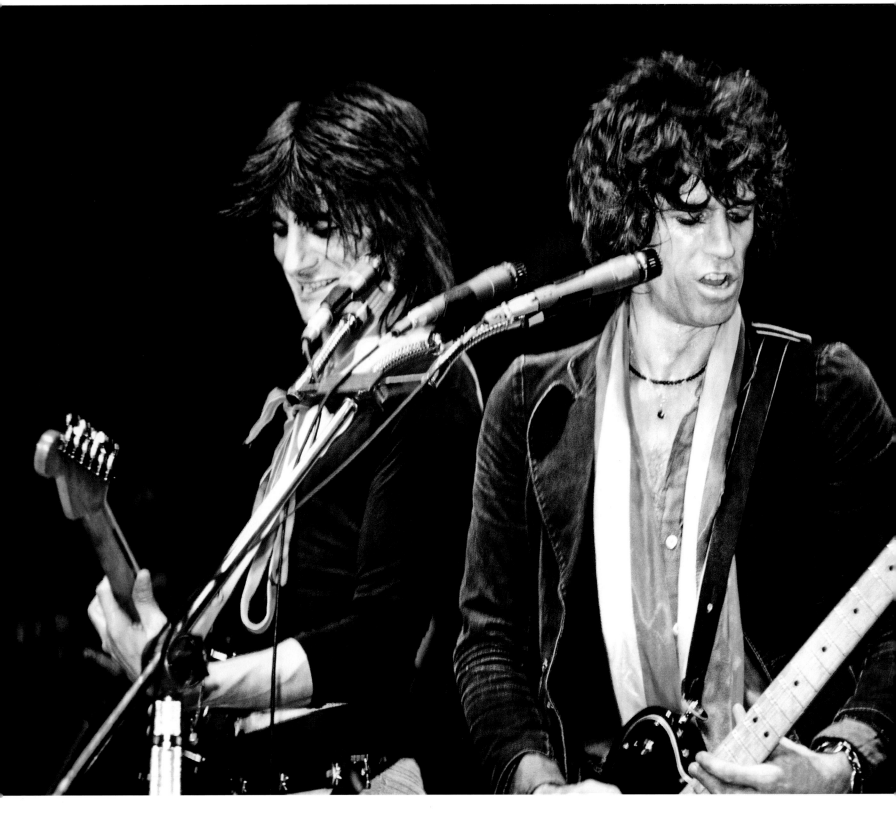

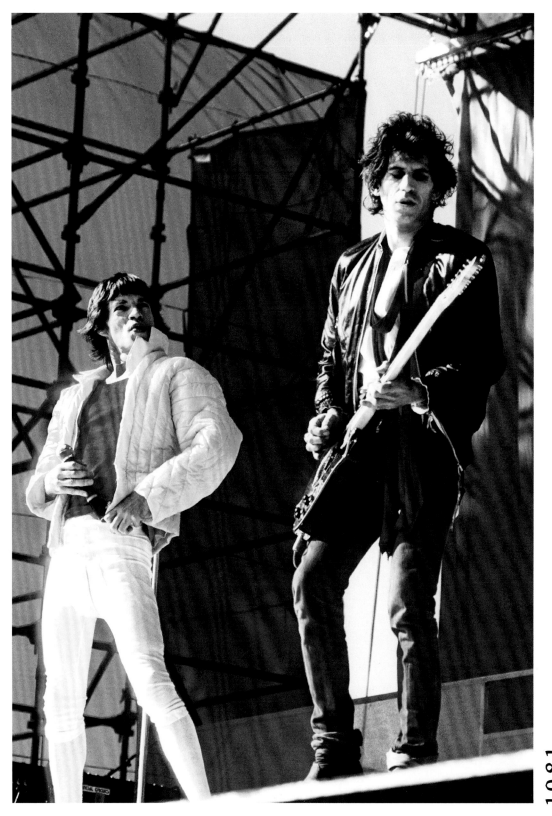

1981 MICK JAGGER AND KEITH RICHARDS. JFK STADIUM, PHILADELPHIA

Chris
MAKOS

This photo was taken in Montauk, Long Island.

I have no memory, so that's why I take pictures ... to remind myself that I actually did things.

I had met Mick a year or so earlier in Paris, playing backgammon with one of the Guinness beer girls or something. We were on the Île de Paris with Fred Hughes [Andy Warhol's assistant] and all those people. Everybody was very chatty and it was cool.

The **Stones** had rented Andy Warhol and Paul Morrisey's house out on Montauk to rehearse for their 1982 North American tour. Andy must have been there, but I don't remember. They were rehearsing at the main house. I was just out there at the time, and I said, "Can I take some pictures?" They said, "Sure," and Keith was holding a skull while the others stood around. It's too hard to get that many people together looking interesting, so I took separate pictures and pieced them together, much the way people would do today with PhotoShop and the computer.

They were all pretty cool and it shows in my photos. They had much fewer wrinkles than they do now.

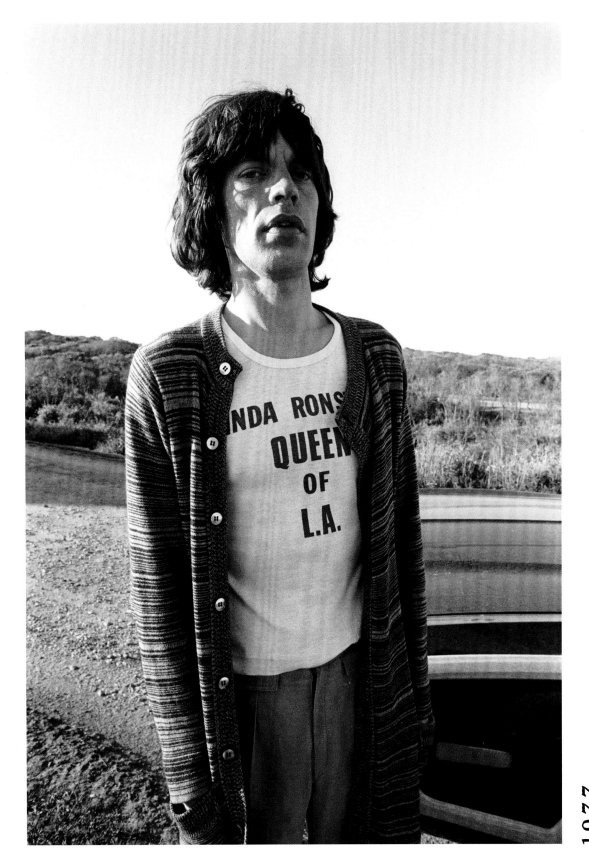

1977 MICK JAGGER. MONTAUK. LONG ISLAND. NEW YORK

William
C O U P O N

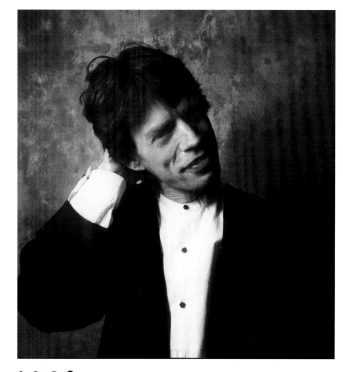

1983 MICK JAGGER, COVER OF *ROLLING STONE* MAGAZINE, NEW YORK

I *took these photographs for a cover of Rolling Stone magazine because Mick's album,* **She's the Boss***, had just come out.* The shoot was weeks in the making because we were waiting for Mick to make the call to say it was OK. I kept being put on hold, not knowing when it was going to happen. Meanwhile, I was asked to do the center for a *New York Times Sunday Magazine* cover story on Elie Weisel, so I spent the whole day shooting him in his house with his wife. At around five o'clock in the afternoon, when I was just about wrapping up, I got a call from **Rolling Stone** saying, "Mick Jagger's at Charivari shopping and he's coming over to your place at seven thirty." I said, "You're kidding me, I'm just wrapping up a shoot here. I didn't know it was going to be that quick. OK, wow."

I got off the phone and said to Elie Weisel, "You won't believe this but I've got to go. I've got a shoot with Mick Jagger at my place." He replied, "Oh, who's Mick Jagger?" I went back home and did the shoot with Mick Jagger, and at the end of it I said to him, "I had a shoot earlier with Elie Weisel," and he said, "Who's Elie Weisel?"

When I showed him my portfolio, Mick said, "So I see we're doing art here, are we?"

I asked him to put on my bathrobe because I liked the color on him. At the end, I asked him if he wanted to do anything else since I had done what I wanted. He said, "Well, heck no, you've already got me in your dressing gown." At one point during the shoot, I went up to Mick Jagger and did, "I'm a monkey!" (I had been doing impressions of him since I was in college.) He just looked at me and said, "Oh my...uugh." The shoot took a while and he hung out at the house with me and my wife at the time. He had a couple of people with him, Laurie Kratochvil, *Rolling Stone* magazine's director of photography, and his stylist. Mick was easy to work with. He was Mr. Charming, really playing into the camera and making the whole shoot progress smoothly.

1983 MICK JAGGER, *ROLLING STONE* MAGAZINE PHOTO SESSION, NEW YORK

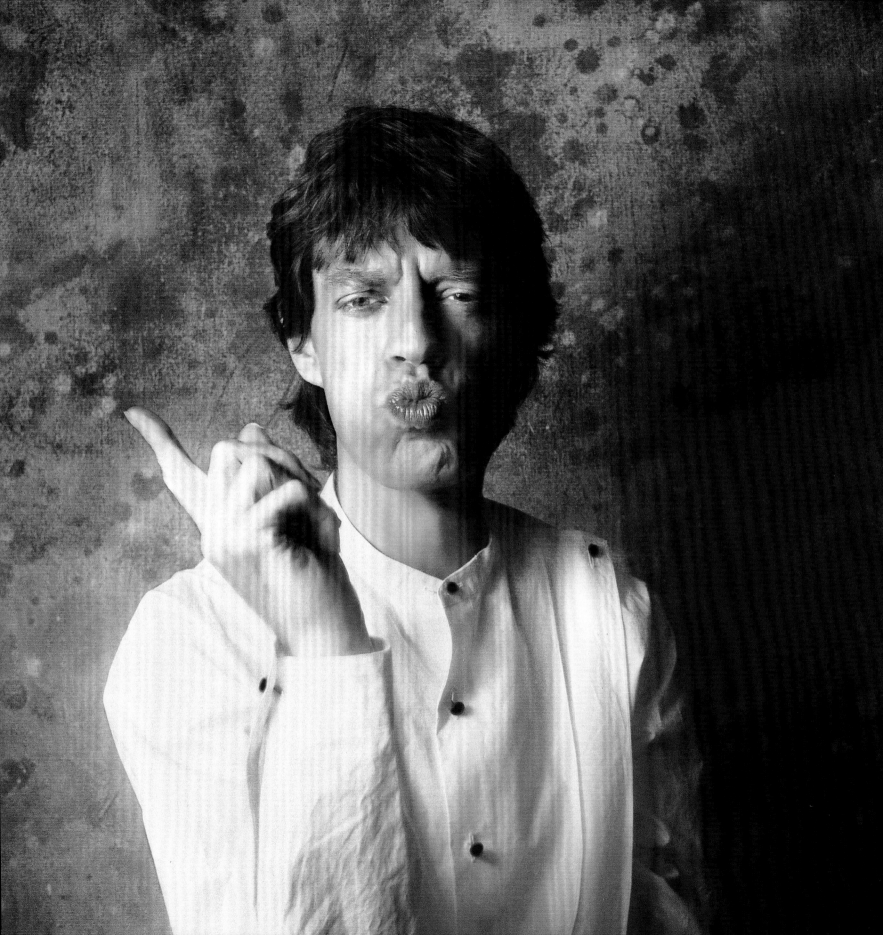

1969 KEITH RICHARDS.
MADISON SQUARE GARDEN.
NEW YORK

David
FENTON

I **was a** *photographer* for Liberation News
Service, which sent out photographs to all the hippie, countercultural,
antiwar community newspapers in the country—kind of the Associated
Press of the underground press. In 1969 I was seventeen years old, and
I was lucky that I had a police press pass that got me into events
for free. I was able to go to Madison Square Garden on November 28,
1969, and stand at the front of the stage and take pictures of the
Rolling Stones, which for a seventeen-year-old at that time
was a pretty thrilling thing. The day before that concert the Stones
held a press conference, and with my police press pass, I was able to go
and get up pretty close and photograph Mick and his very thick lips.

At that time, within my community of activists and alternative
journalists, the view was that the Stones were the political band, much
more than, for instance, the Beatles. The Stones had put out "Street
Fighting Man," "Sympathy for the Devil," "Salt of the Earth"—all those
great songs that had a political conscience. John Lennon was saying,
"You have to free your mind instead," which I actually think now is
true, but at the time that didn't seem quite militant enough.

My photographs got picked up in many of the underground papers
because, in the context of the time, it was viewed as not only great
rock 'n' roll but also as good social and political commentary.

It's hard to think back and understand the sort of cultural unity
that most young people at the time felt. Music was really the primary
method through which that unity was felt and achieved. The musicians
were the role models, and the music itself was rebellious, and certainly
the lyrics were. Why did everybody grow their hair long in the late
sixties? Because the Beatles and the Stones did, and that's the reason.
The mannerisms, attitudes, viewpoints, sexuality, and understanding of
the world were very much a result of the music of the time. The music
was the primary carrier and progenitor of that, both in form and
content, which is why it made most of our parents so uptight.

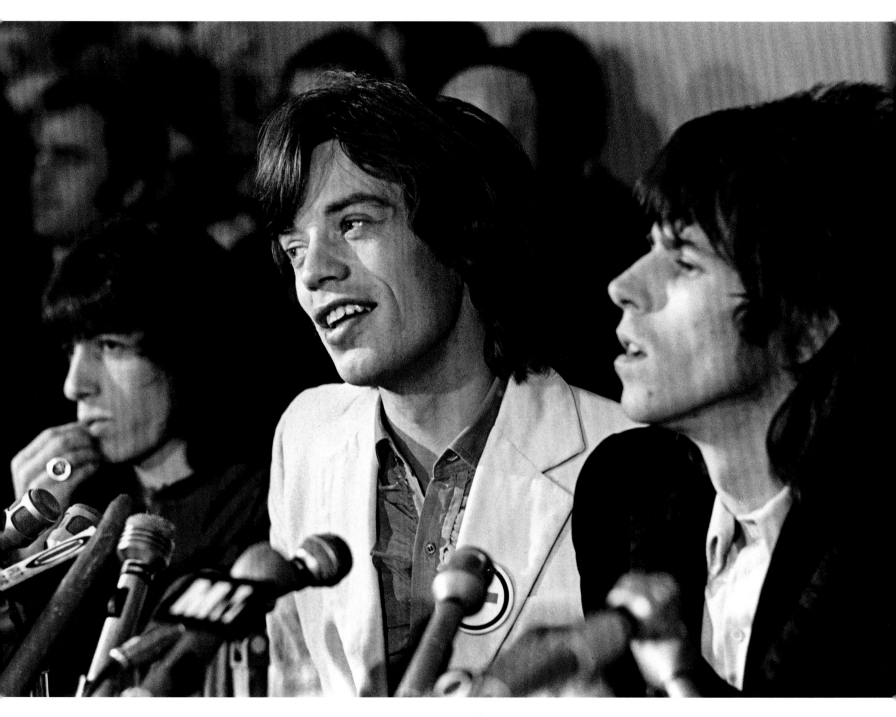

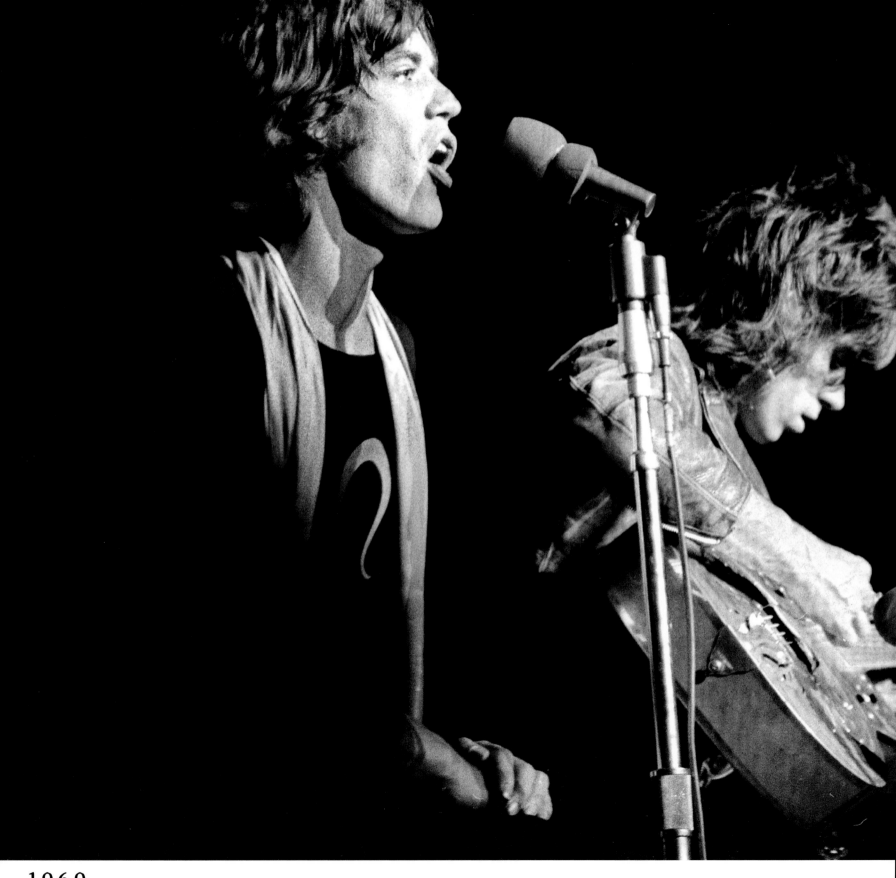

1969 MICK JAGGER AND KEITH RICHARDS, MADISON SQUARE GARDEN, NEW YORK

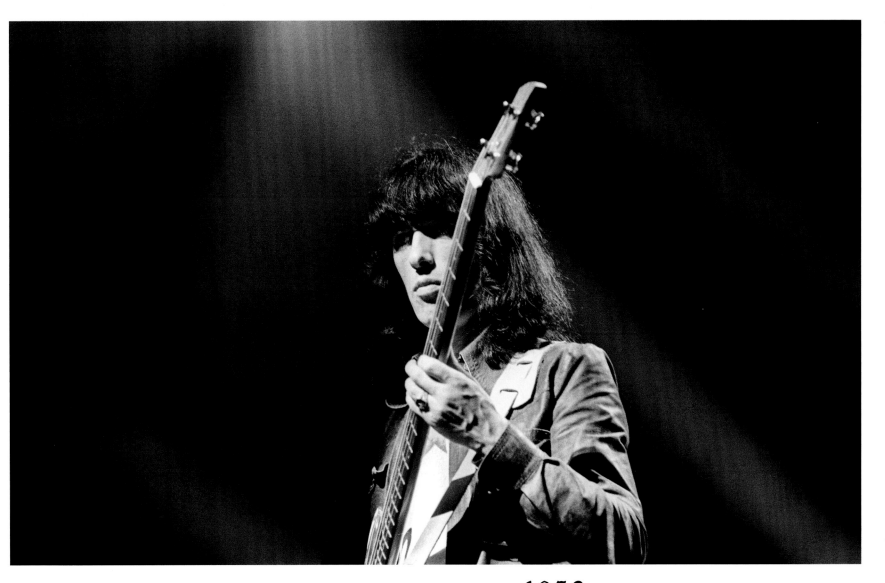

1972 BILL WYMAN. COBO HALL. DETROIT

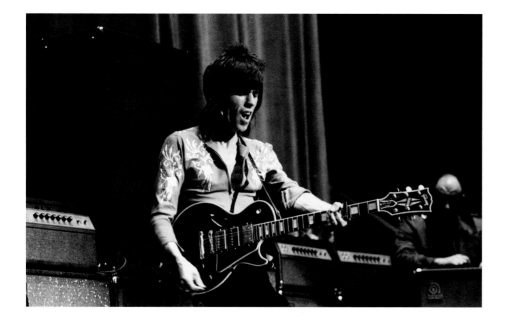

1969 KEITH RICHARDS, MADISON SQUARE GARDEN, NEW YORK

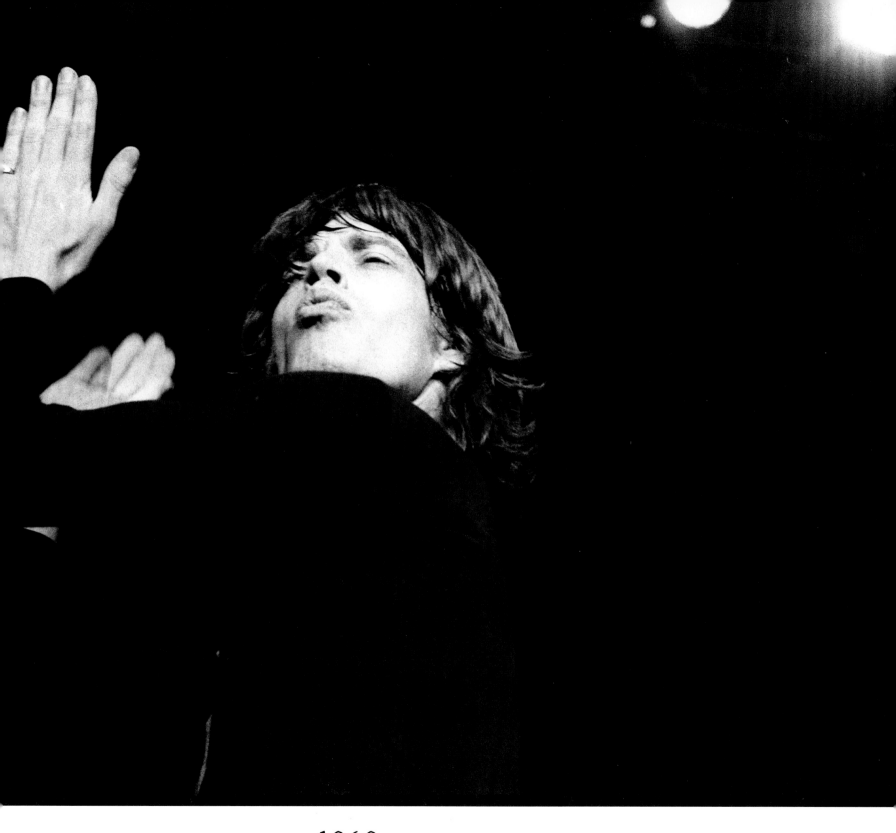

1969 MICK JAGGER, MADISON SQUARE GARDEN, NEW YORK

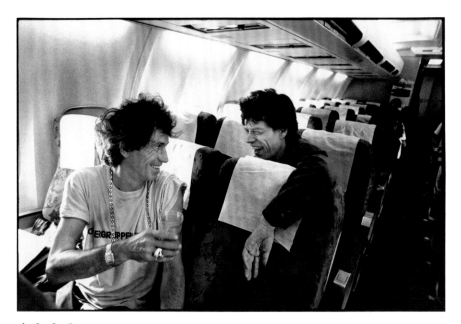

1990 KEITH RICHARDS AND MICK JAGGER, EN ROUTE FROM MADRID, SPAIN, TO MARSEILLE

Claude
GASSIAN

When I first began photographing, my most successful shots were taken at the **Stones'** concerts in the early 1970s. As a novice, I found it easier to hide behind the lights and in the shadows of their overwhelmingly photogenic personalities. I crossed paths with each of them on several occasions throughout the '70s and '80s. The encounters were brief but always incredible and resulted in great images. Keith selected one of my photos, "Antwerpen 1973," for his first solo album, *Run Rudolph Run.* During the '90s, I spent much more time with them on tour and, consequently, had the opportunity to get more intimate, personal shots. These allowed me to express visually what I had experienced through their music.

Much time has passed, yet I still have the impression that the **Stones** haven't really changed. Looking back on my negatives, I relive those great live moments and the excitement I felt capturing them. The visual impact of the **Stones** that so obsessed me in the beginning still endures.

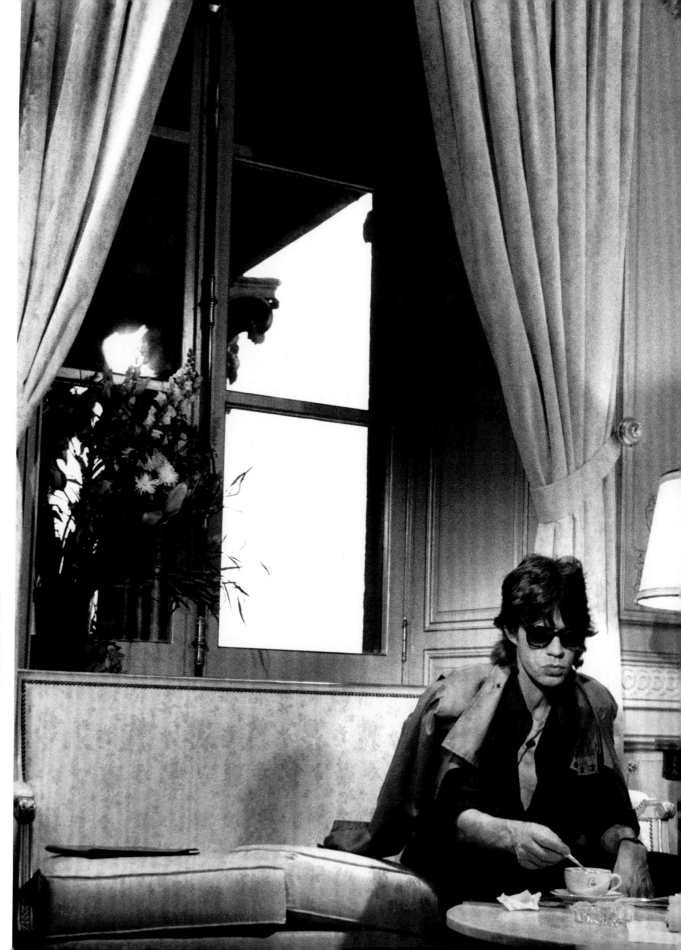

1985 MICK JAGGER. HOTEL DE CRILLION. PARIS

Ross
HALFIN

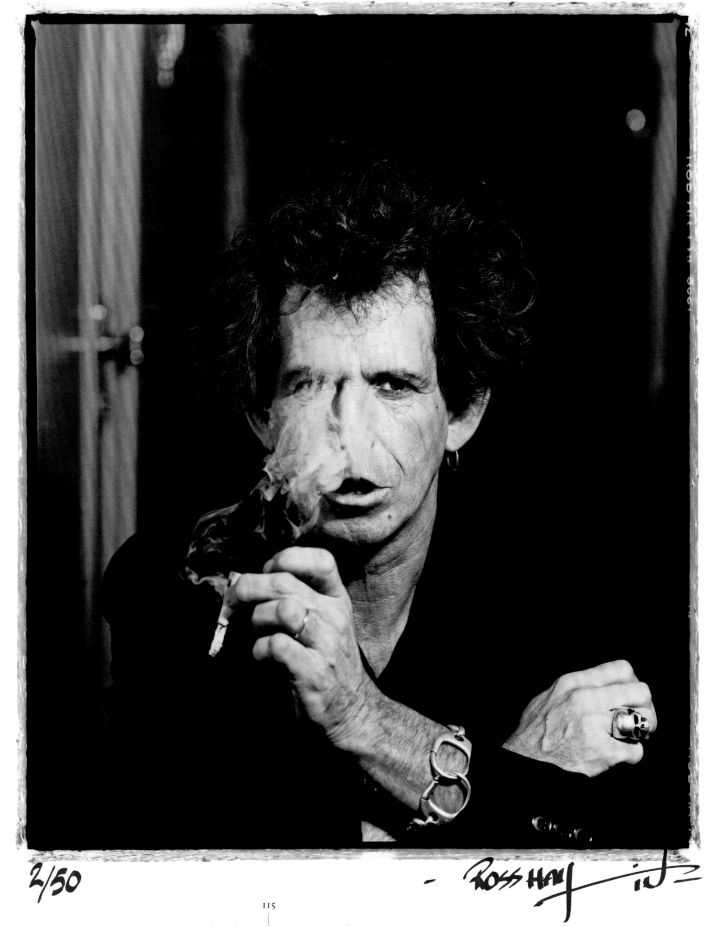

2/50

Ross Hay

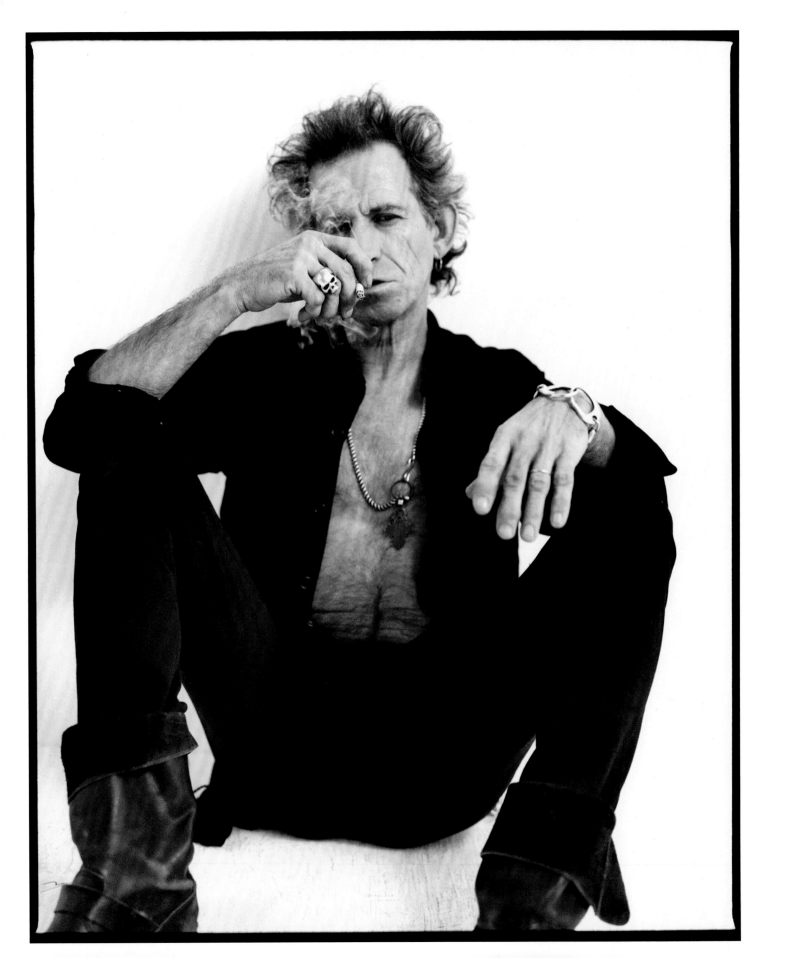

Mark
SELIGER

During a session for Rolling Stone *magazine,* I was shooting individual portraits and, at the end, a group picture. Keith was sitting back, smoking a cigarette, and having a good time. My patience was running a little thin, as it was for everybody, so I said to him, "Keith we've got to take your picture." Keith replied, "Oh, I don't really want to do this, do you? I've been photographed with them for thirty fucking years, and it's fucking boring."

When doing publicity pictures for the *Voodoo Lounge* tour or shooting for **Rolling Stone,** I didn't expect them to be such generous and open guys. There wasn't an overwhelming sense of stardom or celebrity associated with their work. They're just really proud to be doing what they're doing, and to be doing it so well. They were extremely enthusiastic about the album and were playing it nonstop. It's like being at the end of a journey and reaping the rewards of your work.

As a youngster, I listened to a little bit of the *Stones,* but I got my first real taste when I was on a family trip. We stopped for lunch in a crappy little dive on Cape Cod and my brother walked up to a jukebox. The first song that came up was "Sympathy for the Devil," and I thought, "Wow, that sounds amazing!" My first concert was in Texas after the release of *Some Girls* and it was incredible. I was a late bloomer for the *Stones* but I loved them.

I have enormous respect for the *Stones.* Knowing that people can still put it out in such a big way and have a great time is infectious.

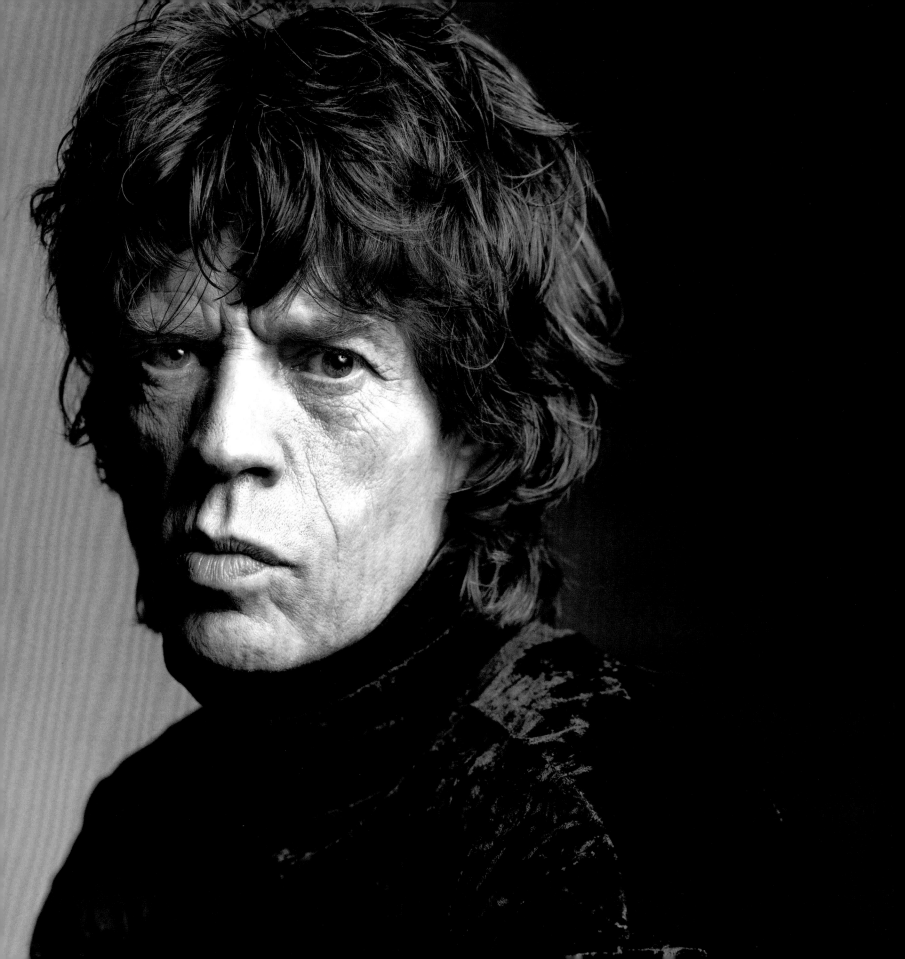

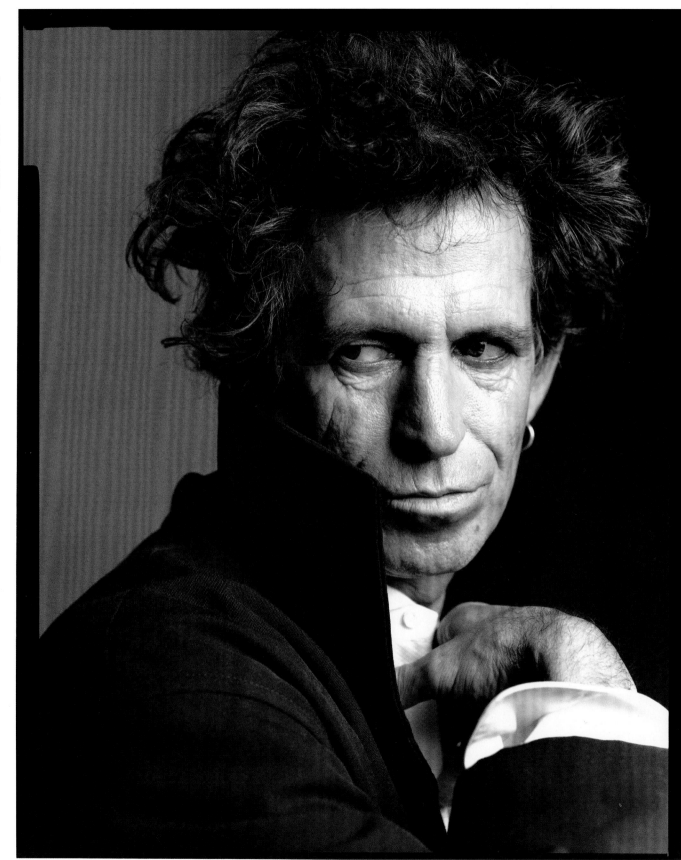

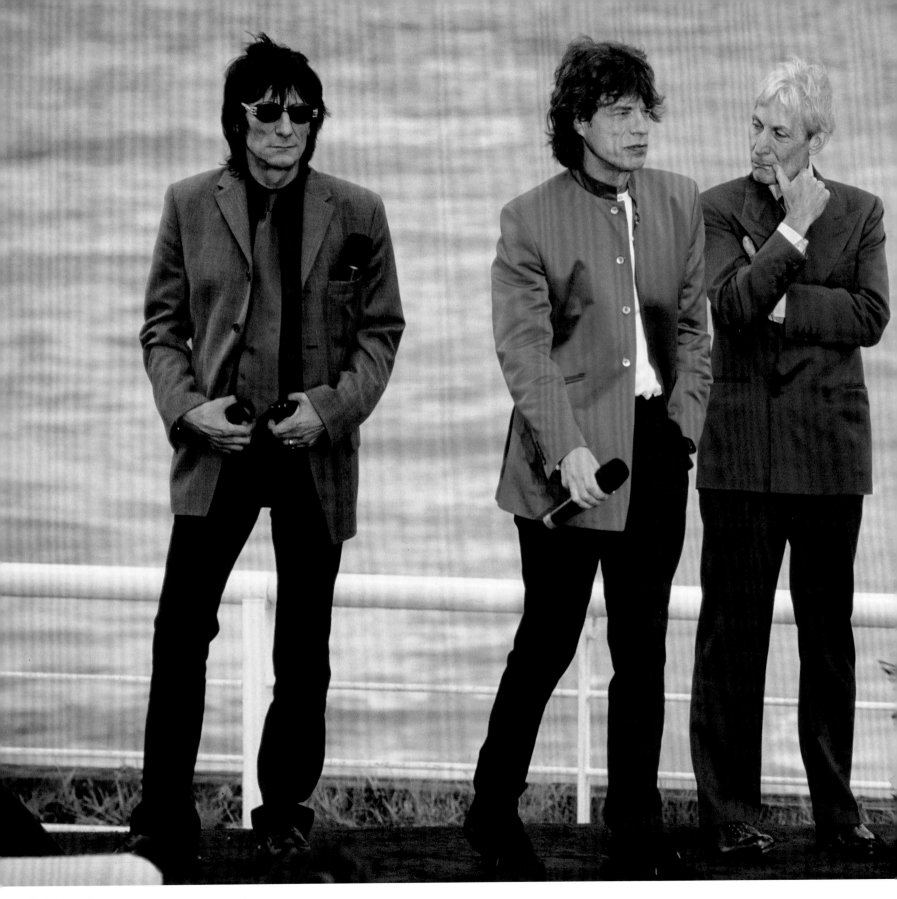

1995 THE ROLLING STONES. BROOKLYN. NEW YORK

The very first time I photographed the Stones was in 1994 at Giants Stadium in New York. I was commissioned by a Mexican promoter, who was bringing the *Stones* the following year to Mexico City and wanted to have some advance photographs for the local press. After shooting the Woodstock festival that summer, I met the *Stones.* I felt the pressure of the shoot as soon as it was over, but in the middle of it, I didn't think about the fact that they were the biggest rock 'n' roll band in the world. Some of the photographs were taken in Mexico City in 1995, in New Jersey, in Montreal, Canada and at Soldiers Field in Chicago during the opening gig in 1997.

In January of 1995, just four days before the *Stones'* first concert in Mexico City, I received a phone call from Virgin Records in Mexico asking me to go on location for the shooting of the video "I Go Wild," from the *Voodoo Lounge* album. The location was very different from any other location in the world—the former temple of Saint Lazarus, a seventeenth-century church. There was a kind of magic atmosphere. It was

Fernando
A C E V E S

funny to see the *Rolling Stones* in a fusion with that old building, as if they belonged to each other. At that time I had a chance to catch some images behind the scenes. I only had two minutes, so it all happened very quickly. In my first encounter with Mick Jagger, he was sitting, looking at me very fast, at my camera and what kind of equipment I was working with. After forty years of being photographed, these people know what they want from a photographer. As a photographer, you don't need to talk to them. They know what they want to show to the audience. They are the directors of themselves.

Photographing the *Stones* was a truly exciting experience. They know each other very well. I understood that for the *Rolling Stones,* playing music was as natural as walking or smiling. I didn't feel any tension, they were just playing from the soul.

As a rock 'n' roll photographer you have to be aware of what you are doing. You have to be conscious that you are making history with your camera. The thing is just to be cool ... and excited. You have to be conscious that the highest point for every rock 'n' roll photographer is to shoot the *Rolling Stones.* There's nothing else in the world after shooting the *Stones.*

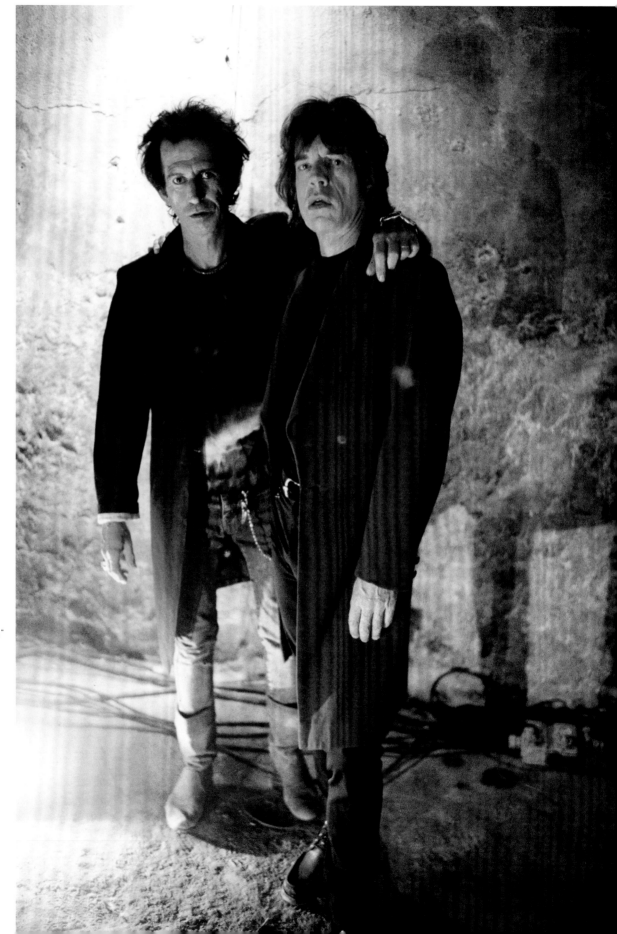

1995 KEITH RICHARDS
AND MICK JAGGER. "I GO WILD."
MEXICO CITY

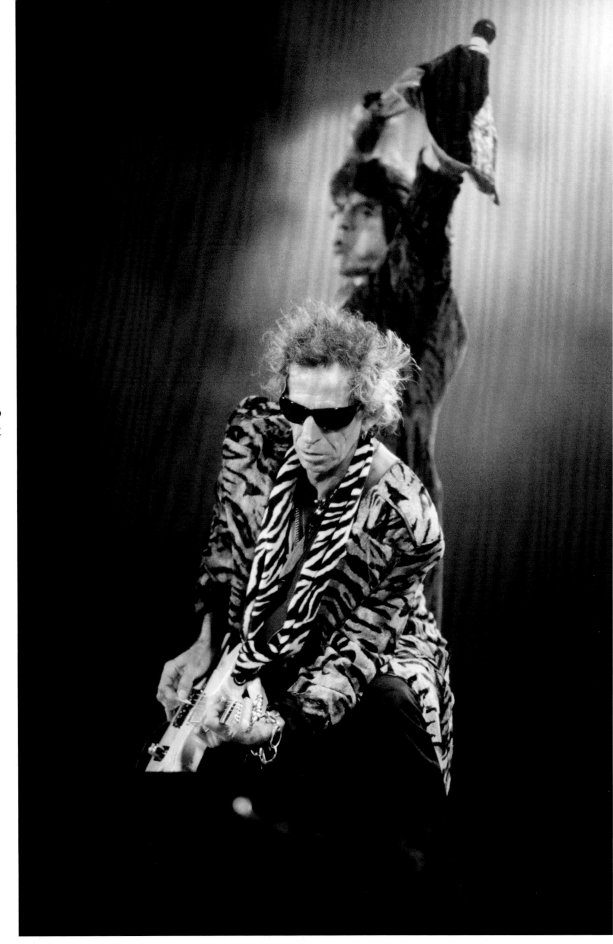

1998 MICK JAGGER AND
KEITH RICHARDS, FORO SOL,
MEXICO CITY

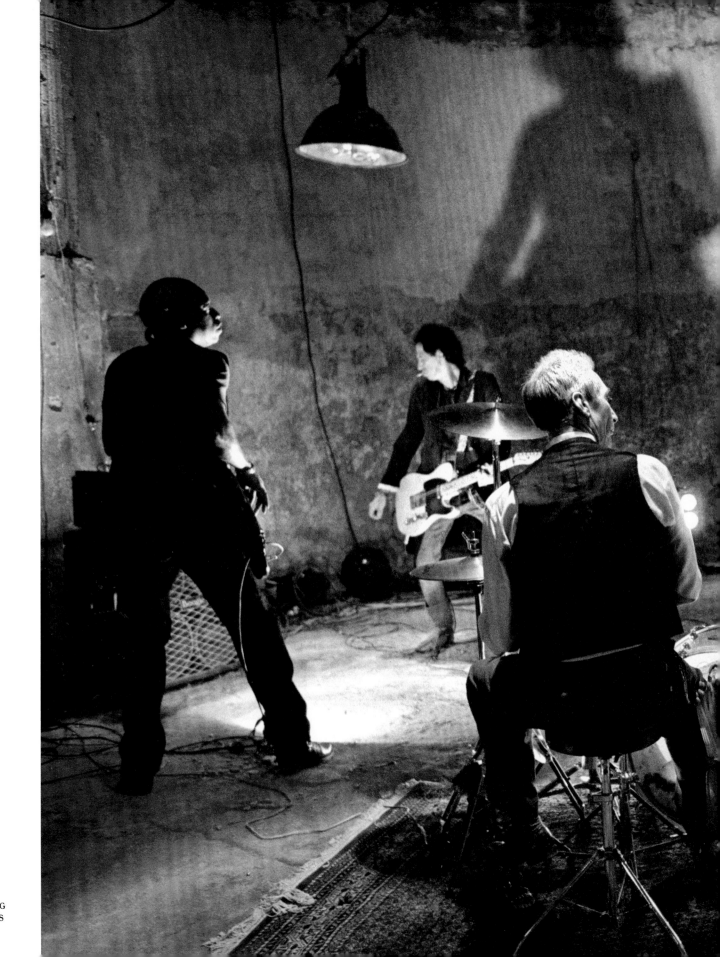

1995 THE ROLLING STONES, SAINT LAZARUS CHURCH, MEXICO CITY

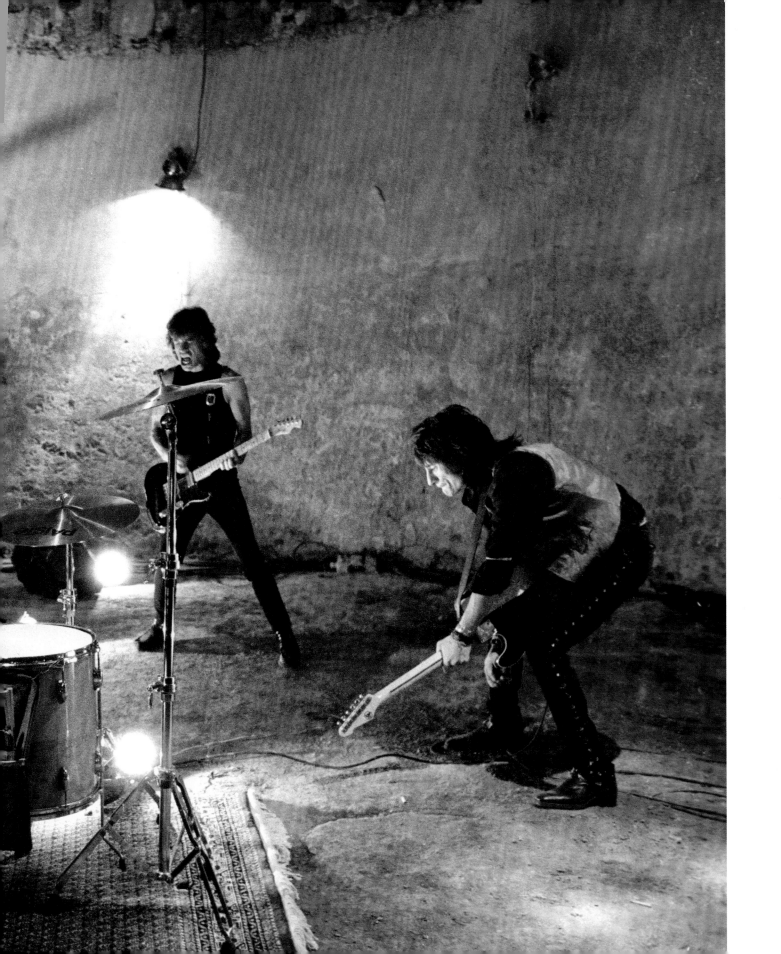

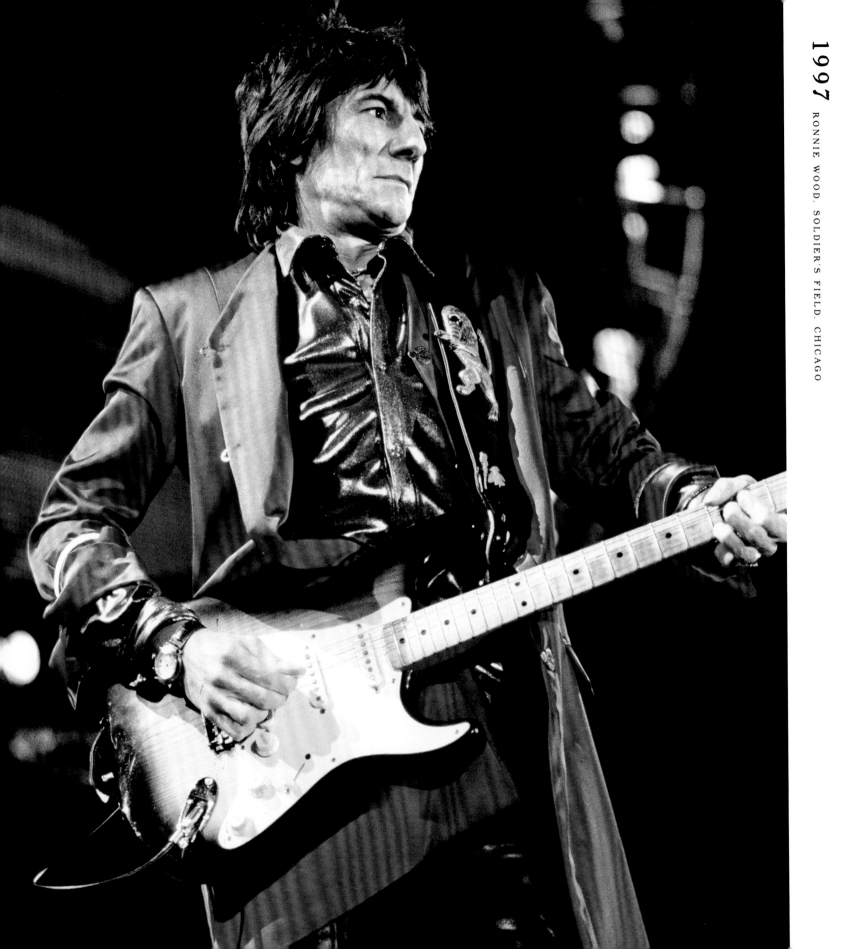

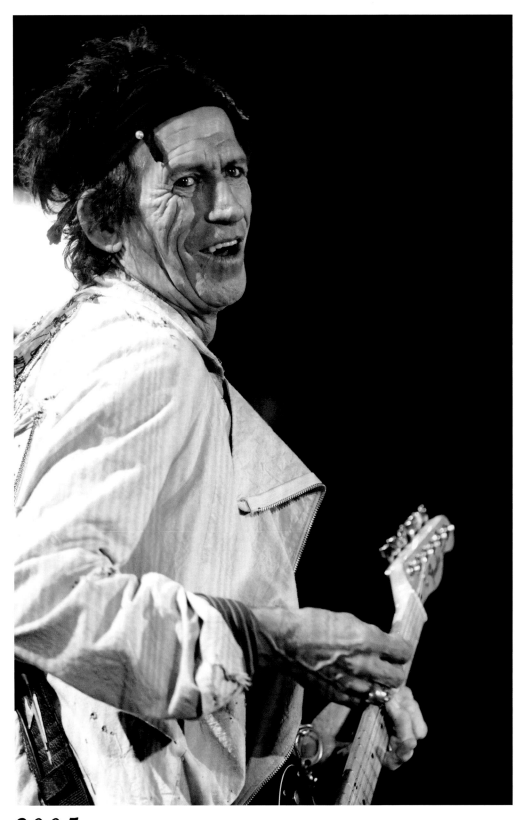

2005 KEITH RICHARDS, A BIGGER BANG TOUR, ANGEL STADIUM, ANAHEIM

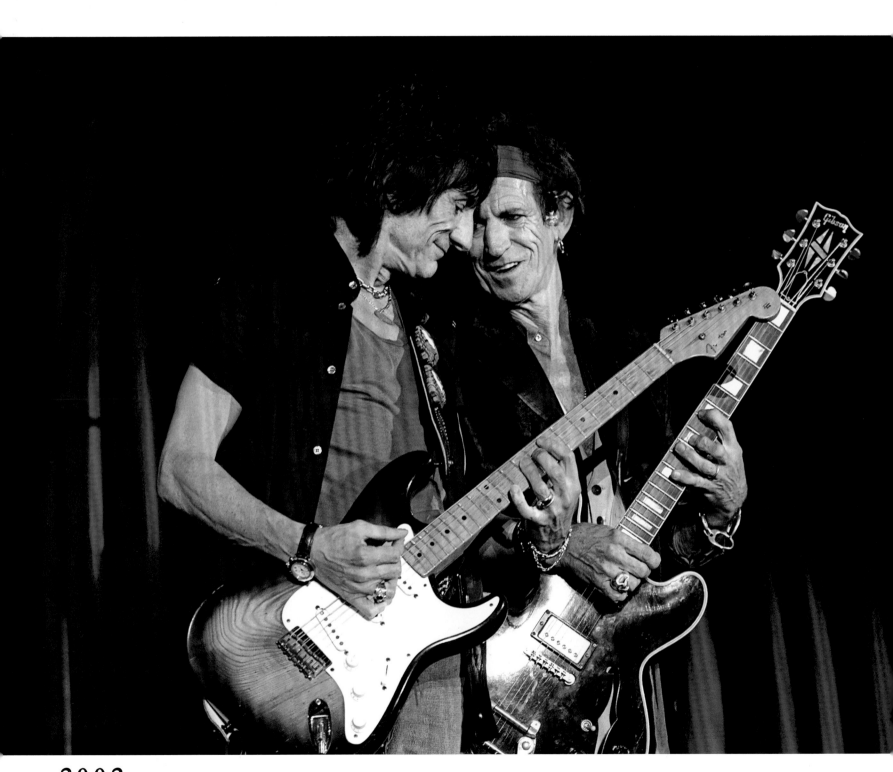

2002 RON WOOD AND KEITH RICHARDS. 40 LICKS TOUR. PHILADELPHIA

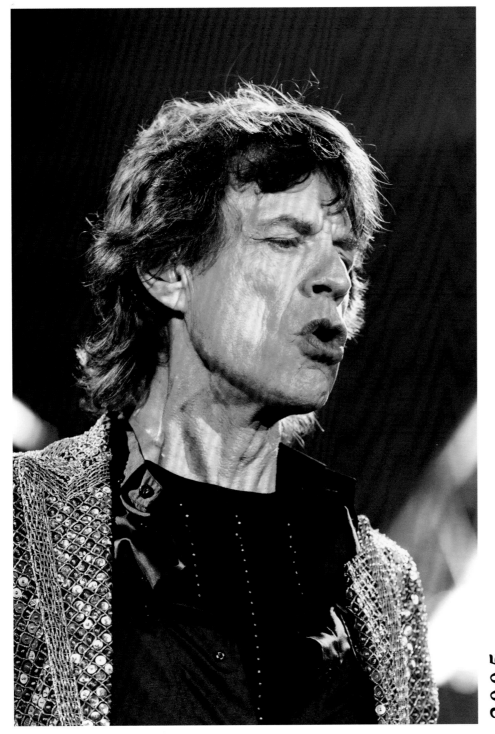

2005 MICK JAGGER. A BIGGER BANG TOUR. ANGEL STADIUM. ANAHEIM

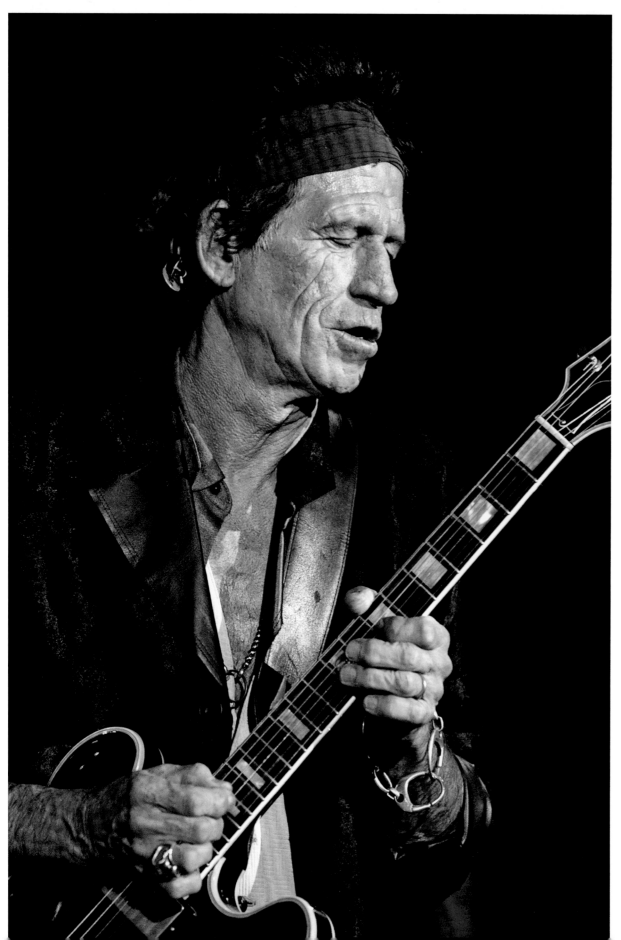

2002 KEITH RICHARDS,
40 LICKS TOUR, PHILADELPHIA

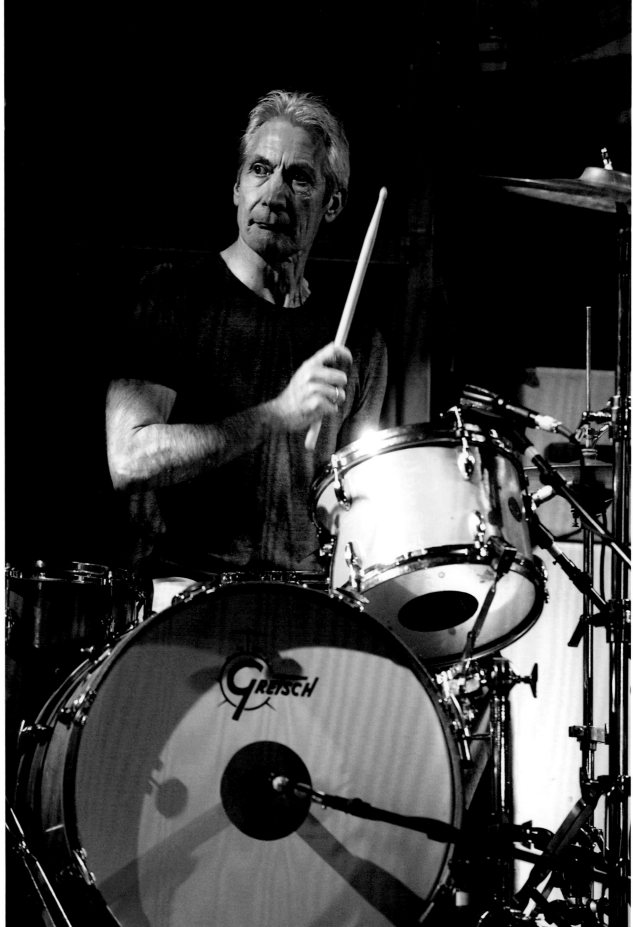

2005 MICK JAGGER.
A BIGGER BANG TOUR.
ANGEL STADIUM. ANAHEIM

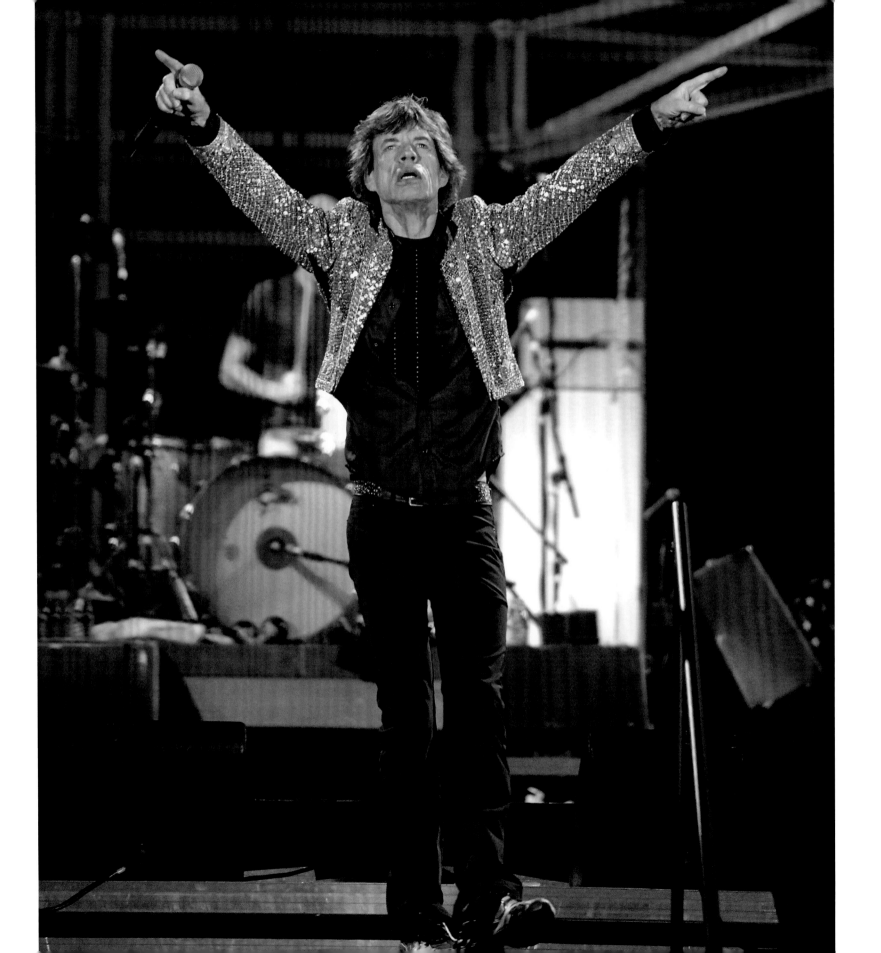

A f t e r w o r D

In his memoir, Popism, Andy Warhol recalled meeting Mick Jagger for the first time. Jagger was with David Bailey, the British photographer, enfant terrible, and one of the singer's closest friends. It was the spring of 1963, and the two were staying at the apartment of *Vogue* art director Nicky Haslam on East 19th Street in New York City. "They each had a distinctive way of dressing—Bailey all in black and Mick in light-colored unlined suits with very tight hip trousers and striped T-shirts, just regular Carnaby Street sports clothes, nothing expensive," Warhol recalled.

Such cheap chic was initially part of the allure of Mick Jagger and the Stones: its impact was revolutionary, wrote Warhol, who is pictured in this collection with Mick in a shot by renowned New York photographer Bob Gruen. Warhol added that the look of the **Rolling Stones**, the Beatles, and the rest of the British invasion had an almost immediate effect on the streets of New York: "Everything went young. The kids were throwing out their preppy outfits and the dress-up clothes that made them look like their mothers and fathers, and suddenly everything was reversed—the mothers and fathers were trying to look like the kids."

Helping to promote this seismic cultural shift was the new, uncharted world of rock photography, open to anyone with talent. In the mid-1960s photographers enjoyed extraordinary access to their subjects in a manner that today would cause apoplexy to the controlling minds of star-making public relations "experts." Many would certainly have been too modest to consider themselves as professional photographers. Inspired, for example, by the now-notorious "Would You Let Your Sister Marry a **Rolling Stone**?" newspaper headline, Bob Bonis had taken the job of tour manager for the Stones' first U.S. shows (and later for the Beatles). Bonis's personal passion was photography: During the 1960s he amassed over thirty-five hundred revealing images of the **Stones**, the Beatles, and other acts, none of them seen until recently. Similarly fortunate was another "amateur," Eddie Kramer. A renowned audio engineer who worked at the Record Plant and Jimi Hendrix's Electric Lady Studios and is credited on many a record sleeve, Kramer had a sharp visual eye. He would punctuate his work with pictures he took in his workplace as iconic acts went about their art.

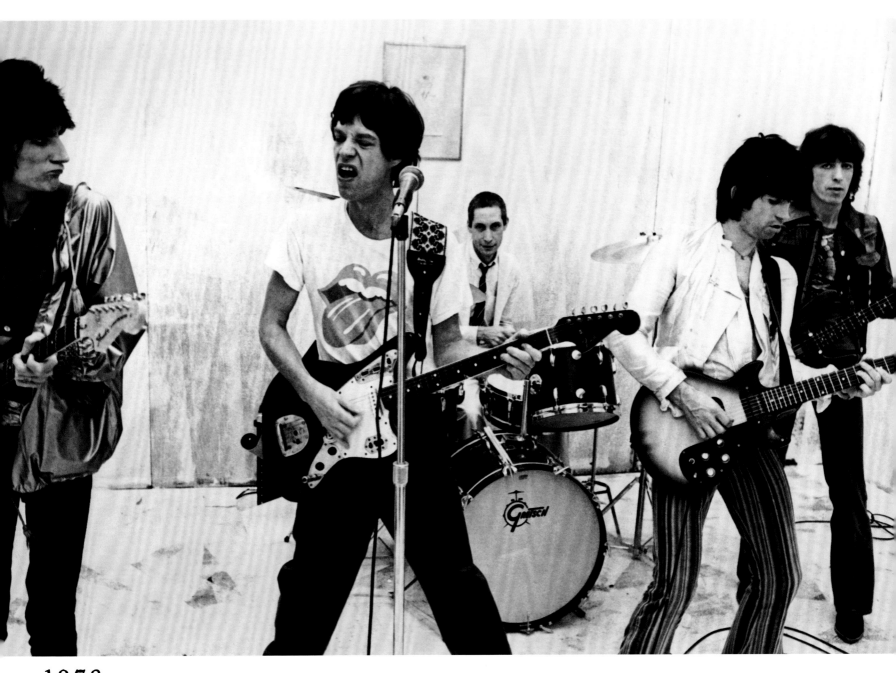

1978 THE ROLLING STONES. "RESPECTABLE"
VIDEO SHOOT (BY MICHAEL PUTLAND)

1994 STAGE AT THE ROLLING STONES CONCERT. OLYMPIC STADIUM. MONTREAL (BY FERNANDO ACEVES)

It was 1963 when Gus Coral photographed the *Rolling Stones'* first UK tour—during their houndstooth jacket era—as they accompanied Bo Diddley, Little Richard, and the bill-topping Everly Brothers through northern England; until recently his pictures had largely gone unpublished. And Eric Swayne was such a significant cast member of early "swinging London" that he was the sweetheart of Pattie Boyd, immediately before she became George Harrison's girlfriend: Mick Jagger and Keith Richards would hang out at the West London Studios where Eric lived.

It was David Bailey, the working-class British photographic king of the new classless British fashion world, who took the cover shot for the *Stones'* second LP, released in its original form in the UK in January 1965. In the picture, Mick Jagger stands at the rear of the group: Bailey said he deliberately placed Mick in that position, so the other group members wouldn't think he was getting special treatment because of his friendship with the singer.

Mick Jagger had met Bailey through Jean Shrimpton, the celebrated British model who was the sister of Chrissie, Mick's girlfriend. But it was another fashion photographer, Norman Parkinson, who established the template for the *Stones'* image of louche decadence in a photo shoot for the high-end men's magazine *Queen*. "When [Mary] Quant's clothes were presented in a 1964 *Queen* fashion spread featuring a model and all of the *Rolling Stones*, shot by Norman Parkinson and headed 'How to Kill Five Stones with One Bird,' the fusion between style and music was sealed," said the British style chronicler Paul Gorman.

But more than Mick Jagger, and certainly more so than the then schoolboy-like Keith Richards, the visual identity of the *Rolling Stones* initially was personified by Brian Jones, the founder of the group and its prime exponent of foppish narcissism. "Brian Jones was the most stylized, and

stylish, British rock star there has ever been," said Gorman.

By 1965, the *Stones* were working regularly with another young photographer, eighteen-year-old Gered Mankowitz, who would soon take the cover picture for the band's *Out of Our Heads* album. Mankowitz was fully aware of who was the star of the group: "In those days Brian had the most formed image, the most evolved image, the most groomed image. He was the one who physically was the most confident. Charlie always had an image. But Charlie's image was a retro image. He was into fifties/early sixties New York jazz and wore suits and interesting jackets and slacks and loafers.

"Mick and Keith were still kids in a way. They were still finding a space, a place. And that's quite apparent in the pictures—it's why Brian appears in the front of the grouping in the *Out of Our Heads* cover. There's no doubt about it: Even from Brian's haircut you can see he really was the most evolved and the most charismatic."

Brian Jones's studied air of dissolute elegance impressed Mankowitz, who clearly saw the group's founder as the archetype of its image. Mick Jagger and Keith Richards seemed more like permanent students. "There was a student-y thing about them, an art school thing. Brian had an element of show business about him. He was more advanced in that way. That's what I mean by charisma. He had a presence to him; he'd got an image together. He'd made a conscious effort to look the way he did. Whereas everybody else was just evolving, Mick and Keith particularly, and shaking off the ordinariness of early sixties British teenagerhood."

One morning as dawn broke in November 1966, Mankowitz accompanied the *Stones* from an all-night recording session to the leafy, sloping piece of London parkland known as Primrose Hill. The musicians were wearing a selection of outfits from Granny Takes a Trip, the hippest—and druggiest—of London's new boutiques. "The Stones always recorded

through the night," said Mankowitz, "and I thought that their look after one of these grueling sessions might capture an image that would be right for the time. At about 5:30 A.M. we all set off in a procession of limousines for Primrose Hill."

The trippy feel of the resulting images was achieved with the photographer's "rather clumsy" filter of black card, glass, and Vaseline, but it worked, creating an ethereal, spacey look. "In spite of Brian Jones being rather unhelpful some of the time, and all of us feeling the bitter early morning chill, the photos turned out better than I could have wished for," the photographer modestly recalled.

Four months later, on a trip to Marrakech, a famous photographer entered the orbit of the group's principal triumvirate. "They were a strange group," wrote Cecil Beaton, the society photographer and painter, in his diary in March 1967. "The three Stones: Brian Jones and his girlfriend Anita Pallenberg—dirty white face, dirty blackened eyes, dirty canary drops of yellow hair, barbaric jewelry—Keith R. in eighteenth-century suit, long black velvet coat and tightest pants, and of course, Mick Jagger. He is sexy, but completely sexless. He could nearly be a eunuch. As a model, he is a natural. None of them is willing to talk, except in spasms. No one could make up their minds what to do, or when."

That trip to Morocco turned out to be traumatic for Brian Jones, as Keith Richards disappeared with Brian's girlfriend Anita Pallenberg. Brian's time with the Stones would soon be over. Early in June 1968, Brian had become extremely nervy, at least according to Michael Joseph—better known at the time for his corporate photography—who shot a series of Hogarthian portraits for what would become the inner sleeve of the *Beggars Banquet* album. During shoots at Sarum Chase in Hampstead, north London, and later at Swarkestone Hall Pavilion in Derbyshire, Joseph noted that Brian was extremely worried about the consequences of his pending June 11 court

appearance following his second marijuana bust in May. Perhaps this explained his appearance, like that of a deranged hobbit. "Brian was upset at having been busted, but he had a Labrador to play with," said Joseph, who nevertheless recalled the two shoots as "wild and hugely memorable."

Meanwhile, the *Beggars Banquet* sleeve outer image was the cause of considerable controversy, which held up the release of the new record (itself a masterly change of creative pace). At the suggestion of the group, Barry Feinstein shot a cover image in a graffiti-covered toilet in a Porsche repair shop in Los Angeles: The album's song titles were added as part of the graffiti. The record company found the image shocking, and the LP's release was delayed by six months while they sought a compromise. Hence, *Beggars Banquet* eventually appeared as a plain white gatefold, with the Michael Joseph shots in the center spread.

When the **Stones'** next album, *Let It Bleed*, was released a year later, Brian Jones was dead, in arguably mysterious circumstances, and he had been replaced by blue-eyed, angel-faced Mick Taylor.

With Mick Jagger and—when not hampered by his drug consumption—Keith Richards now firmly in charge of the **Rolling Stones**, the group confidently moved into its next phase: that of "The Greatest Rock 'n' Roll Band in the World." They traversed the world's arenas and stadiums with a series of epic, seemingly endless tours. Ironically, it was as they began their lengthy but sure trajectory toward what would become "corporate rock"—flabbergastingly, their 1997–1998 *Bridges to Babylon* tour was sponsored by Castrol Oil—that the Stones became the darlings of the "underground." Accordingly, they were suitable subjects for the likes of Baron Wolman, who had become principal photographer for the iconoclastic *Rolling Stone* magazine, a then-new, apparently unique portal to the zeitgeist. Wolman's specialty

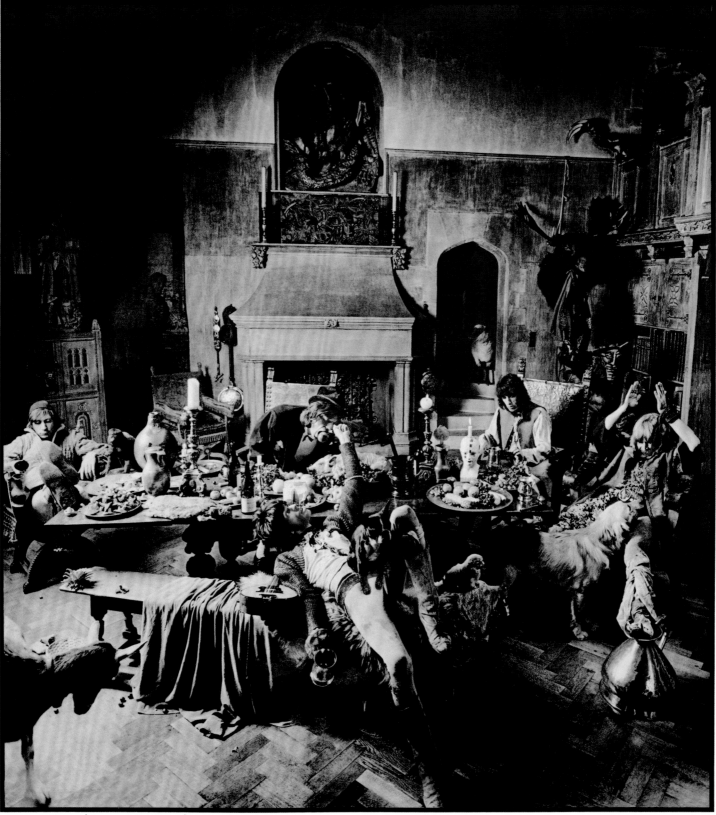

The Rolling Stones "Beggars Banquet" London 1968 Michael Josep 28/250

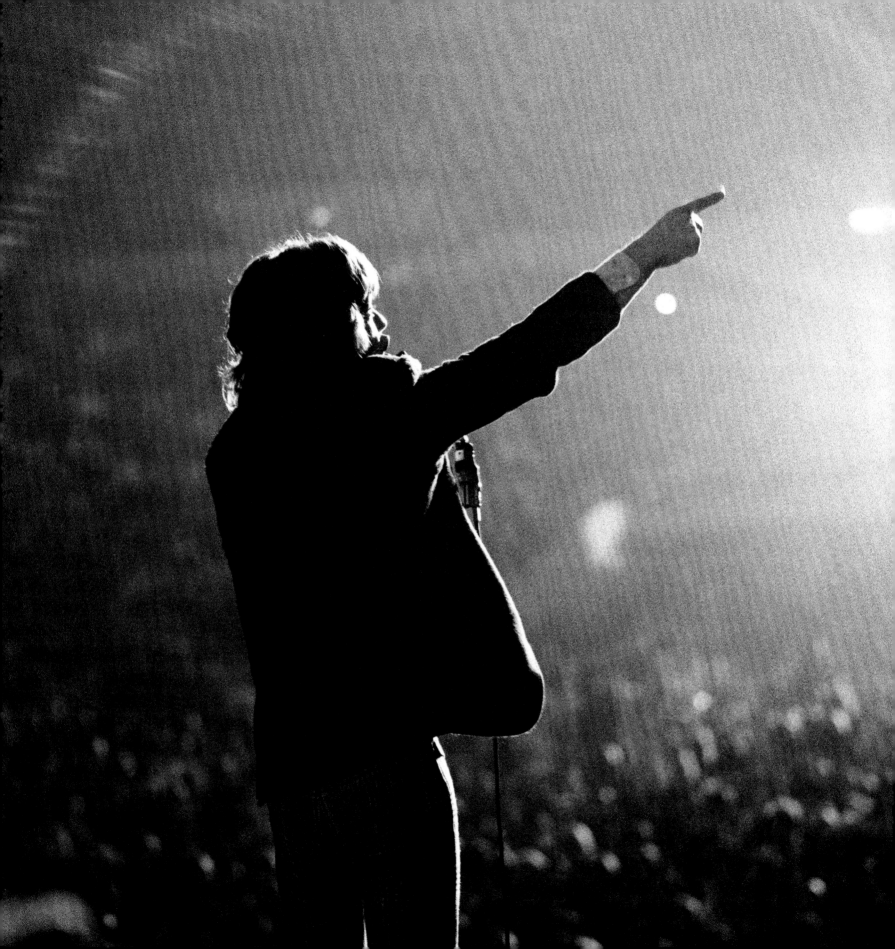

was capturing his subjects in informal portraiture, as appropriately precise a mirror of this allegedly democratically radical time as the publication for which he worked.

Another leader of the U.S. underground media was David Fenton, still a teenager. More accustomed to photographing antiestablishment demonstrations and figureheads, the young photographer was attracted to the *Stones'* rebellious countercultural status, and he took a selection of poignant pictures during their concert at Manhattan's Madison Square Garden in late 1969.

The band's enhanced credibility, with Mick Jagger for a time seizing the mantle of Spokesman for a Generation once worn by Bob Dylan, pulled the *Stones* into the trajectories of other respected photographic artists: Dick Waterman, for example, renowned for his writing and photography of blues artists, accompanied the group on their European dates in 1970. In France, meanwhile, Claude Gassian developed a series of portraits of legendary musicians, including the *Rolling Stones*, from 1970 until the present day.

Promotion of musical acts in the UK, which lacked a distinct radio network, was very dependent on exposure in the music press. By 1970, five weekly publications were dedicated to music of various sorts. Among the several celebrated photographers supported by this fortuitous system was Michael Putland, initially attached to *Disc* and *Music Echo*. Famously, in 1971 Putland had been about to throw in the towel as a photographer when the publication called him to commission a Mick Jagger session. Two years later, Putland was selected as the official photographer on the Stones' 1973 European tour, and he saw photographic service on video shoots, such as for the "It's Only Rock 'n Roll" single, with the *Stones*—milking the contemporary glam rock mood—campily attired in sailors' outfits.

Back in the U.S., William Coupon had graduated to shooting covers for *Rolling Stone*. Coupon's images of Mick Jagger evolved from the photographer's late-1970s anthropological studies of lower Manhattan youth, largely derived from the Mudd Club. For those photos he would use a portable studio, with a formal painterly background applied in most situations; Mick Jagger's mutating appearance—by now, in the punk manner, his hair short and his trousers tight—eminently qualified him for such an approach. Later, Coupon refined this technique as he documented indigenous people around the globe.

Meanwhile, a new generation of rock photographers emerged in 1980 with the advent of the UK's *Kerrang!* magazine. Ross Halfin, its star photographer and cofounder, soon found himself taking iconic images of members of the *Rolling Stones*, notably of the self-styled World's Most Elegantly Wasted Human Being, Keith Richards.

Another young photographer, who was not even born when the *Rolling Stones* made their first records, emerged from south of the U.S. border. Honing his chops as a concert photographer, Fernando Aceves developed into a master of the genre, with a distinct personal vision, at a time when the value of rock photography was initially unrecognized in his native Mexico. His youthful passion for both rock 'n' roll and photography drew him to work in the United States, United Kingdom, and Canada on the *Rolling Stones'* *Bridges to Babylon* tour in the 1990s. Times have changed, however, and Fernando Aceves is now the official photographer of the National *Auditorium* in Mexico City.

Fifty years from their humble beginnings in small London clubs, the *Rolling Stones* today remain globally ubiquitous, their image perhaps eternalized. You can't help but wonder what precisely Brian Jones would have thought of the giant behemoth that the group he founded has become.

—Chris Salewicz

C o n t r i b u t o r S

Born in Mexico City in 1965, *Fernando Aceves* is the only Mexican photographer focusing on music full time. Self-taught, Aceves documents Mexican and international contemporary musicians and has worked with major stars, such as Paul McCartney, Pink Floyd, and David Bowie, among others. In 2000 the Museum of Modern Art of Mexico City presented his acclaimed exhibition, *The Rolling Stones*. Working with 35mm film, Aceves uses available light in making his photographs. Two books of his photographs have been published: *Illusiones y Destellos: Retratos de Rock Mexicano* and *50 Jazzistas Mexicanos*. Aceves is the official photographer of the National Auditorium in Mexico City.

Tour manager for both the Beatles and the Rolling Stones during their first U.S. tours in 1964 and in 1966, *Bob Bonis* learned early on to take his camera wherever he went, resulting in remarkably intimate photographs. In addition to more than 3,500 photos he took of the Beatles and the Stones, Bob photographed Simon & Garfunkel, the Hollies, Cream, the Lovin' Spoonful, Buddy Rich, Frank Sinatra, and many of the jazz greats. Bonis's photographs have been unseen for over forty years until their recent publication.

British born photographer *Michael Cooper* spent several years in the sixties as the "court photographer" to the Rolling Stones. During this time, he worked with several other leading musical talents, such as the Beatles, Eric Clapton, and Marianne Faithfull. Deeply rooted in the London art and music scene, Cooper also worked as a staff photographer at *Vogue*. A book of Cooper's Stones photography, *Blinds and Shutters*, was published in a limited edition in 1989 and first exhibited at Govinda Gallery in Washington D.C. Cooper's photographs are also featured in the book *Michael Cooper: You Are Here—The London Sixties*, edited by Robin Muir, and in *The Early Stones*, edited by Perry Richardson.

Gus Coral began photographing the Rolling Stones at the start of their first tour through Northern England in 1963. On that tour, the Stones performed with their musical heroes Little Richard, Bo Diddley, and the Everly Brothers. Coral caught up with the Stones in concert in Cardiff, Wales, and went on to document the Stones at one of their first recording sessions at EMI Studios in Holborn, London. Coral was a full-time photographer in London and photographed a wide variety of subjects, but has said that his work with the Rolling Stones in 1963 was "close" to his "heart." Coral first exhibited his photographs of the Rolling Stones at the landmark exhibition *Rolling Stones: 40 x 20* at Govinda Gallery in Washington, D.C., in 2002.

William Coupon began taking formal studio portraits in 1979 while observing lower Manhattan youth and counterculture. He developed a portable studio with a single-light source and a simple mottled backdrop and used it to document global subcultures. Beyond this "personal work," as he refers to it, Coupon has also had a very successful commercial photography and film career, featuring fifteen *Time* magazine covers, including portraits of every president starting with Richard Nixon.

The creator of many of the entertainment industry's most compelling visual images, *Barry Feinstein*'s work has appeared in *Life*, *Look*, *Time*, *Esquire*, *Newsweek*, and scores of European magazines. The exclusive photographer on Bob Dylan's 1966 European tour and the 1974 Dylan/The Band tour, he has photographed more than 500 album covers for musicians, including Janis Joplin, George Harrison, Donovan, and Miles Davis, as well as many Hollywood and political figures. He is the recipient of over thirty U.S. and international art director and photojournalism awards.

David Fenton started his career as a photojournalist in the late 1960s, taking pictures for the Liberation News Service. His book *Shots: An American Photographer's Journal* (Earth Aware Editions, 2005) documented political demonstrations in the United States. It was during this time that Fenton photographed the Rolling Stones. He was formerly director of public relations at *Rolling Stone* magazine and coproducer of the "No-Nukes" concerts in 1979 with Bruce Springsteen, Bonnie Raitt, Jackson Browne, and other artists. In 1982 Fenton started a communications firm called Fenton, dedicated to public relations campaigns for the environment, public health, international development, and human rights.

More than simply portraits of well-known musicians and performers, *Claude Gassian*'s photographs are part of his greater search for that beautiful moment beyond the immediately recognizable. In the early 1970s, Gassian traded his guitar for a 35mm camera and began photographing his favorite musical artists. Over three decades later, he has developed one of the most significant visual archives documenting the icons of contemporary music. Many of Gassian's images have been used as album covers and have been published in numerous magazines and newspapers throughout the world. Gassian's photographs were featured in a one-person exhibition at Les Rencontres d'Arles Photographie in Arles, France. His first exhibition in the United States was held at Govinda Gallery in Washington, D.C., in 2007. He lives in Paris, France.

According to rock 'n' roll photographer *Bob Gruen*, "You have to see the photo, feel it, and be part of it." Shot with the Canon EOS1 system, Gruen's images of rock legends, such as John Lennon, Sid Vicious, Kiss, Jimmy Page, Chuck Berry, the Who, Bob Marley, and Madonna, have achieved iconic stature. Featured in numerous museum and gallery shows, his pictures also appear in magazines worldwide, such as *People*, *Rolling Stone*, *Newsweek*, and *Mojo*. Several books of Gruen's photographs have been published, including *Crossfire Hurricane* (1997).

While studying fine arts at the Wimbledon School of Art, *Ross Halfin* picked up a Pentax Spotmatic and tried his hand at photography. He began sneaking his camera into rock shows and sending his photos to the London music papers. His pictures began to be published just as punk became big, leading him to photograph the Clash, the Sex Pistols, and Blondie, among others. He spent most of the 1980s touring with bands like Iron Maiden, Metallica, Def Leppard, Kiss, and Mötley Crüe, and was tour photographer for Paul McCartney, George Harrison, and the Who.

Born in South Africa in 1941, *Michael Joseph* grew up with a father involved in the Anti-Apartheid movement. This instilled a devotion to social and political issues that was only strengthened by his time photographing the Vietnam War. Joseph went on to make a name for himself as a photographer in the advertising industry. Joseph is best known for his photograph of the Rolling Stones that was used for the jacket of the Stones' album *Beggars Banquet* in 1968. The weekend-long photography session took place at Saram Chase, the former home of Victorian society painter Frank Owen Salisbury, and reflects the richly illustrated style of painting of the era. In 2003 *Beggars Banquet* was ranked number 57 on *Rolling Stone* magazine's list of five hundred greatest albums of all time.

Eddie Kramer is mostly known as a producer and engineer for the biggest names of an era that he likes to call the "Golden Age of Rock 'n' Roll." Kramer had the opportunity to take intimate pictures of musicians such as Jimi Hendrix, the Stones, and Led Zeppelin, by virtue of his close working relationship with them in the recording studio. Kramer has said that photography allowed him to satisfy the other side of his creative brain.

Christopher Makos burst onto the photography scene in 1977. Andy Warhol, his good friend and frequent portrait subject, called Makos "the most modern photographer in America." His photographs have been exhibited in galleries and museums, such as the Guggenheim Museum in Bilbao, the Tate Modern in London, Govinda Gallery in Washington, D.C., the Whitney Museum of American Art in New York, the IVAM in Valencia (Spain), and the Reina Sofia Museum in Madrid. His pictures have appeared in magazines and newspapers, including *Paris Match* and *The Wall Street Journal*. He is the author of several important books, including *Warhol/Makos in Context* (2007), *Andy Warhol China 1982* (2007), and *Christopher Makos Polaroids* (2009).

British photographer *Gered Mankowitz* is a legend on the music photography scene. His photographs of the Rolling Stones, Jimi Hendrix, the Yardbirds, Marianne Faithfull, Traffic, and many more, helped define the visual identity of numerous musical artists. Mankowitz accompanied the Rolling Stones on their first major tour of the United States. It is Mankowitz's photographs of the band that appear on the covers of *Between the Buttons*, *December's Children*, as well as other album jackets from Rolling Stones recordings. Numerous books of his work have been published, including the landmark *Rolling Stones: Mason Yard to Primrose Hill* 1965–1967 (1995) and *Eye Contact* (1998). His photographs have been exhibited in galleries and museum around the world, including the National Portrait Gallery in London and in the museum exhibition *Sound and Vision: Monumental Rock & Roll Photography*, currently touring the United States.

In the music industry, *Jan Olofsson* is known as the owner of a record label, publisher, manager, producer, club owner, and record promoter. As a photographer, he is known for his images of some of the great musicians and performers of the 1960s, including the Beatles, the Rolling Stones, the Kinks, the Who, Sonny and Cher, Stevie Wonder, Ike and Tina Turner, and James Brown. Olofsson compiled an extensive collection of photographs documenting Cuba in the 1990s. After living in England for four decades, Olofsson now resides in his native Sweden.

Michael Putland began his career at sixteen, when he left school to work in a London photography studio. While working as the official photographer for *Disc & Music Echo* and then *Sounds* magazine, Putland first photographed Mick Jagger. He became the tour photographer for the Rolling Stones in 1973, leading to a long relationship with the band. Putland's photographs of the Rolling Stones are featured in his book *Pleased to Meet You* (1999). In the foreword to *Pleased to Meet You*, Mick Taylor writes that Putland's photos "are personal, intimate, and revealing . . . a wonderful collection of the Stones."

A native Texan, *Mark Seliger* worked as the chief photographer for *Rolling Stone* for more than ten years before joining Condé Nast publications with *GQ* and *Vanity Fair*. Seliger has published several books and codirected numerous music videos with Fred Woodward. In addition to shooting many advertising campaigns and music-packaging projects, he has been recognized by his peers with accolades and rewards. Seliger's photographs have been exhibited in galleries and museums internationally.

Born in the East End of London, *Eric Swayne* picked up a camera for the first time at the age of twenty-nine. He began photographing his circle of friends, including David Bailey, Terence Donovan, and several of the actors, models, and stars in London's scene during the '60s. Swayne's fresh reportage style and open access to the iconic faces of the time, explains his as-yet unseen body of personal work that eloquently evokes the excitement, innocence, and hope of that unique time, capturing so many legends just at that precious moment when, unbeknownst to them, they were on the cusp of greatness.

Thirty years ago, *Mark Weiss* began shooting covers and features for major rock magazines, such as *Circus*, *Rolling Stone*, *Creem*, *Hit Parader*, *Faces*, and *Rock Scene*. Since those early days, Mark has been on the road capturing some of rock 'n' roll's biggest icons on stage and behind the scenes. He has shot numerous album covers, including Twisted Sister's *Stay Hungry* and Bon Jovi's *Slippery When Wet*. Mark Weiss first photographed the Rolling Stones in concert on June 17th, 1978, at Philadelphia's JFK stadium when he was just nineteen. Without a photo pass, Mark still had to sneak his cameras into the concerts; he slept outside the stadium the night before to get close to the stage.

Baron Wolman was *Rolling Stone* magazine's first chief photographer. Wolman took up residence in San Francisco in 1967 and began to photograph rock musicians. During this time his photographs of the Rolling Stones, Janis Joplin, the Who, Jimi Hendrix, Bob Dylan, Steve Miller, the Grateful Dead, and many others, were published in *Rolling Stone*. Wolman's covers for *Rolling Stone* magazine are featured in his book *The Rolling Stones Years*. Baron Wolman's photographs are one of the single most important documents of the revolutionary music scene that took place in California during the 1960s and early '70s.

C OLOPHO N

Publisher: Raoul Goff

Acquiring Editor: Robbie Schmidt

Editor: Chris Murray

Associate Managing Editor: Jan Hughes

Production Manager: Jane Chinn

Insight Editions would like to thank featured photographers, Chris Murray and Govinda Gallery, Steve Korte, Chrissy Kwasnik, Jenelle Wagner, Binh Matthews, and Jeff Campbell—and of course, a big thanks to the **Rolling Stones**.

A CKNOWLEDGMEN T S

A heartfelt thanks to all of the photographers in this book. Their images, like the **Rolling Stones**, will endure. I am grateful to my editorial staff, Gabby Fisher, Carol Huh, Liz Murdock, and Vivienne Foster at Govinda Gallery. My thanks to everyone at Insight Editions. Special appreciation to Robbie Schmidt for her steady hand. Thanks to my friend Jim Morrissey, who went to the first **Stones** concert with me in New York City, to Tom Beach for our trip to see the Stones in Atlanta, and to Chuck Rendelman and Jim Callaghan for the show in Las Vegas. A very special thank you to the beautiful Caroline Clements and Isobella Work. My appreciation to Chris Salewicz and Richard Harrington for their insightful essays. Thank-you to Lely Constantinople and to Carlotta Hester. And most of all, thanks to the **Rolling Stones**, who rock my world.

—Chris Murray, *Govinda Gallery*